IMAGES
of America

BEECHVIEW

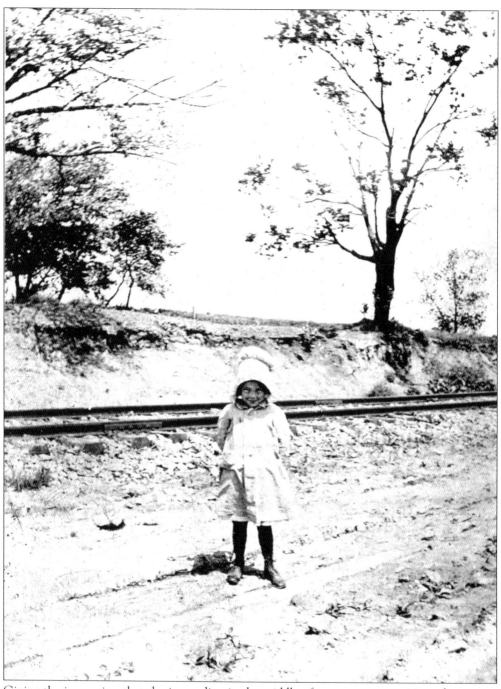

Giving the impression that she is standing in the middle of a vast, empty prairie, a diminutive Neeld granddaughter poses beside the newly laid streetcar track near the corner of Broadway and Neeld Avenues. The year is 1904. With the advent of the trolley, Beechview's landscape would change forever. (Courtesy Donald P. Neeld.)

IMAGES
of America

BEECHVIEW

Audrey Iacone, Anna Loney, Nate Marini, and Robert Thomas
for the Beechview Centennial Celebration Committee

ARCADIA

ISBN 0-7385-3788-8

First published 2005

Published by Arcadia Publishing,
Charleston SC, Chicago IL, Portsmouth NH, San Francisco CA

Printed in Great Britain

Library of Congress Catalog Card Number: 2004117973

For all general information, contact Arcadia Publishing:
Telephone 843-853-2070
Fax 843-853-0044
E-mail sales@arcadiapublishing.com
For customer service and orders:
Toll-free 1-888-313-2665

Visit us on the Internet at www.arcadiapublishing.com

On the cover: Students of Beechwood Elementary School work in their summer garden in 1916.
(Courtesy Historical Society of Western Pennsylvania.)

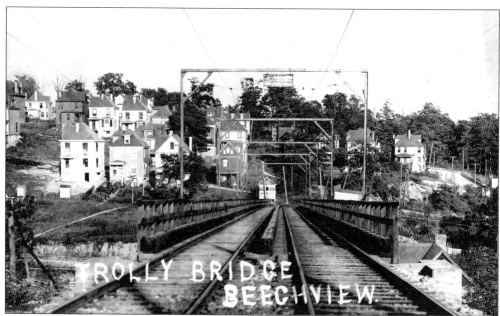

The Mt. Washington Street Railway Company built three trolley bridges (or viaducts) for the
Beechview line during 1903 and 1904. The first crossed over Saw Mill Run and Boggs Avenue, and
the second went over Brookside Avenue. This early postcard shows the third bridge, the Cape May
Viaduct, which passed over Cape May, Dagmar, and Kenberma Avenues. The bridge was 450 feet
long and bore double tracks. Booth and Flinn were the contractors. (Courtesy Paul Dudjak.)

CONTENTS

ACKNOWLEDGMENTS

The following fine individuals contributed to the completion of this book: Michael Murphy of the Allegheny County Prothonotary's Office; Barry Chad, Marilyn Holt, Gilbert Pietrzak, and Lucille Tomko of the Carnegie Library of Pittsburgh, Pennsylvania Department; Gregory Priore of the Carnegie Library of Pittsburgh, Special Collections; David Grinnell, Arthur Louderback, and Kerin Shellenbarger of the Senator John Heinz Pittsburgh Regional History Center, Library and Archives; Frank Stroker III of the Pittsburgh History & Landmarks Foundation, Archives; Valerie J. Baldwin of the U.S. Department of the Interior, Office of Surface Mining, Mine Map Repository; Linda Kasiorek of the Fair Oaks of Pittsburgh administrative office; Michael Dabrishus and Miriam Meislik of the University of Pittsburgh, Archives Service Center; Pamela Seighman of the Penn State University-Fayette, Coal and Coke Heritage Center; Marilyn Evert of Homewood Cemetery; and Tom Olivo of the City of Pittsburgh Department of Public Works. Individuals who provided editorial assistance are Bernard Beranek, associate professor of English at Duquesne University; Tina Zubak of the Carnegie Library of Pittsburgh; Sabina Marini; and Doris Priore. John Weinhold helped considerably with research; and Anthony Iacone demonstrated digital-scanning expertise.

The authors and the members of the Beechview Centennial Celebration Committee wish to express our deepest appreciation to all of those individuals who rummaged through attics and hunted through closets for photographs and documents relating to Beechview. We are indebted to them for sharing images, information, and family stories. Without their support, we could not have accomplished our goal: to compile an interesting and, we trust, accurate account of the history of Beechview.

To the residents of our town—past and present, living and deceased—we dedicate this book. This is your story.

INTRODUCTION

Black bears, panthers, gray wolves, hares, beaver, white-tailed deer, foxes . . . these were the first inhabitants of the region. For thousands of years, Woodlands Indians traversed the ridges and valleys of Western Pennsylvania, passing through, never claiming permanent possession. Seneca, Shawnee, Delaware, and Iroquois came later and created semipermanent villages.

Eventually, Europeans journeyed here. Dutch explorers and British and French soldiers arrived. Ownership of these lands was contested by the French and British from 1754 to 1763 in the conflict known as the French and Indian War. The area was also claimed by both Virginia and Pennsylvania, and for a few years was part of Yohogania County, Virginia. In 1780, however, Pennsylvania claimed ultimate possession and the area became part of Washington County.

Allegheny County, formed in 1788, was composed of seven original townships. From St. Clair Township, Beechview and other southern communities would later develop.

During the 1700s, settlement in this area was sparse. The onset of the Revolutionary War and troubles with the Indians further discouraged migration over the Allegheny Mountains. Soldiers, granted land here for service in the war, journeyed westward with their families and meager possessions to claim their new homesteads. Others sold their tracts without ever setting foot in the territory. Beechview's story begins with those first settlers—English and Scots-Irish pioneers—who bravely endured hardships to secure a livelihood for themselves and a future for their children.

Purportedly named for the many beech trees growing on its hillsides, Beechview was originally settled in the late 1700s. Although the earliest settlers were typically farmers, Irish and Welsh immigrants soon followed to toil in the many area coal mines. The mid-1800s saw the arrival of German truck farmers. A small German community known as Shalersville developed adjacent to Beechview; this section now forms part of the Seldom Seen Greenway. Italian and Jewish families began arriving in the years prior to World War I. Today, the population reflects a rich diversity, including descendants of the early settlers, as well as the addition of African American, Hispanic, Asian, and Middle Eastern residents.

Beechview, now a neighborhood of the city of Pittsburgh, lies about 2.5 miles directly south of the Point. It stretches along a broad ridge that rises to a peak of more than 1,200 feet, beyond the south end of Beechview Avenue. Its streets rise and fall steeply over the flanks of hills that plunge almost vertically down to the four valley roads that serve as the community's boundaries: Saw Mill Run Boulevard, West Liberty Avenue, Banksville Road, and to a partial extent, Wenzell Avenue.

At the turn of the 20th century, the area now known as Beechview straddled sections of Union Township and West Liberty Borough. The district sustained a quiet rural community, its farmers, miners, and shopkeepers maintaining an easy interdependency. In 1902, the Beechwood Improvement Company began buying up parcels of land in West Liberty Borough and in Union Township. Eventually, five plans were sectioned into lots and streets. The same developers also initiated the construction of a tunnel under Mt. Washington and undertook the placement of trolley tracks along the ridge, connecting it with the city. The company promoted the healthful benefits of living outside of the city and the speed with which one could travel into town. Inner-city residents, tired of crowded and smoky living conditions, responded. The completion of the trolley tracks in 1904 stimulated the community's commercial and residential expansion, just as the developers had intended.

In April 1905, inhabitants of the tiny community of Beechwood, Union Township, petitioned the Court of Quarter Sessions of Allegheny County to separate from Union Township and to be incorporated as the borough of Beechview. Several landowners (Bulfords, Reeses, McGuires, and Goodspeeds) decided not to participate, so the petition was amended. The borough's incorporation papers, dated July 28, 1905, include a map of the original section of Beechview. It is this 1905 incorporation that the community will celebrate in 2005.

The court decreed that the first election of borough officers should be held on August 22, 1905. The first meeting of the newly elected borough council was held on August 31, 1905, at the home of George N. Hobson. From 1905 through the end of 1908, the council addressed numerous issues: garbage collection; sidewalk, sewer, and streetlight installations; the grading of streets; tax collection; and the construction of an elementary school.

To the east of Beechview lay West Liberty Borough. Pittsburgh annexed both communities in January 1909, and part of West Liberty was then absorbed into Beechview. The other portion east of West Liberty Avenue became Brookline. The community of Shalersville was annexed by the city of Pittsburgh in 1924.

Today, Beechview is a residential neighborhood replete with many amenities, including a branch of the Carnegie Library of Pittsburgh and the Beechview–Seldom Seen Greenway, which spans more than 90 acres of rugged, undeveloped woodland. Broadway Avenue carries a modern light-rail line through the heart of the community, transporting thousands of commuters between the suburbs and downtown daily.

In 2004, the Beechview Centennial Celebration Committee was formed to commemorate the community's anniversary in 2005. The committee has planned activities including a parade, essay contest, cookbook, memorial quilt, and the planting of a beech tree. A time capsule will be placed in Monument Parklet, at the corner of Shiras and Broadway Avenues. The time capsule is to be opened in 50 years, in July 2055.

One
OUR HILLS DEFINE US

Directions of the compass may mean less to inhabitants of Pittsburgh and its environs than altitude. Hills and valleys shape our lives. In Beechview, residents contend with the city's steepest road grades and streets like Belasco and Napoleon, which pick up and leave off purely because of terrain. Many streets that appear on the city map, like Milo, are actually sets of city-maintained steps that provide unusual but practical paths.

In 19th-century maps of the area, roads and railways reflect the contours of the land, naturally following valley bottoms and gentler grades. Many of these roads remain today, modernized and renamed many times over. The earliest and major valley roads bordering Beechview are today's Sawmill Run Boulevard, Banksville Road, and West Liberty Avenue. Rising over the hilltop to connect valley roads were Crane and Wenzell. Other roads ascended the hill, namely Cape May, Curran Hill, and Pauline from the east; and Goldstrom and a now-unconnected Cagwin from the west.

The 1904 trolley tunnel through Mt. Washington effectively opened Pittsburgh's south suburban development. Earlier area planners and developers had envisioned street grids, but the Beechwood Improvement Company's strategy for a new community along the ridge was accomplished. In 1905, the new Beechview Borough Council began attending to the community's needs. Sidewalks, boardwalks, and footways were provided for by local ordinance. It was illegal to drive carts, wagons, or animals upon them. Other incidental ordinances of 1905 forbade gambling, fighting, the discharge of firearms, and free-roaming animals.

Though Beechview no longer included open expanses of farmland, horsepower still played a vital role in delivering goods and building materials. Available local transportation at the time of Beechview's birth was by foot, horse, train, or electric streetcar. Little did anyone foresee the passenger automobile. This is evidenced by the lack of provision for space to park and garage them. The opening of auto tunnels—the Liberty Tubes in 1924 and the Fort Pitt Tunnels in 1960—provided commuting alternatives to Pittsburgh, but created parking problems that remain today. The trolley line, which has grown into a fast and efficient light-rail vehicle system, may be the most fortunate legacy of Beechview's planners.

Despite the ongoing effort required by life on a hill, and days where snow and ice force us inside, we gain remarkable vistas, areas so inaccessible they remain wooded, and a community unique among the hills.

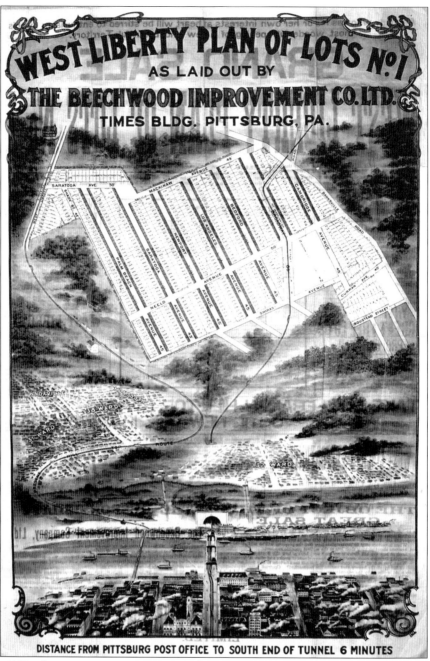

This *c.* 1902 advertisement presents a new plan of lots for sale in the "beautiful territory south of Mt. Washington" and only six minutes from downtown to the south end of the new tunnel! In the West Liberty Plan, which would eventually cover Beechview in homes, street names were chosen to evoke ideas of stately, exciting, or even exotic locales of the day, such as Los Angeles and Palm Beach. There was some early confusion over the use of the name Beechwood. On September 11, 1905, the new borough council discussed soliciting rail companies and the Beechwood Improvement Company for signs that used the name "Beechview" instead. (Courtesy Historical Society of Western Pennsylvania.)

Anybody who has his or her own interests at heart will be stirred to enthusiasm by this most wonderful opening of a new and beautiful Territory.

GRAND SALE
WEST LIBERTY PLAN OF LOTS No. 1

This matchless project will push faster the hands of the great commercial clock. Will command improved high-speed traction service remarkable for its safety devices and unparalleled traveling power.

The busy man will be able to sleep a half hour later in the morning and still be at his desk or shop at the regulation time. A whole new city, in fact, has been moved as if by some impossible, most marvelous change from beyond Mount Washington's hills to almost in front of the Pittsburg Postoffice.

To give this Property its first Boom, Choice Lots will go at

$50-$75-$100-$150-$175-$200

$250-$300-$350-$400 to $500.

TERMS.

$10.00 Down and **$1.00** a Week
Balance Onward

NO TAXES, NO INTEREST FOR TWO YEARS.

10 PER CENT. DISCOUNT FOR CASH.

A Policy of Insurance guaranteeing title of property and issued by the Guarantee Title and Trust Company, will be given FREE to each purchaser.

GENERAL WARRANTY DEED.

Our Deeds will contain no restrictions, except the building line. They will be in fee-simple—free and clear of all encumbrances.

WEST LIBERTY'S GREAT FREE LOT PROPOSITION !!

In order to start "building" with a rush we've decided to give SEVEN LOTS ON SEVEN DIFFERENT STREETS FREE TO THE FIRST PURCHASERS completing the first seven houses, exceeding the cost $2,000 each. This is a proposition that is bound to receive appreciation on all sides. No wide-awake investor will dilly-dally about snapping up such a grand money-saving inducement on property having such an unmistakable future.

WEST LIBERTY'S COLOSSAL HIGH-SPEED TRACTION ENTERPRISE WILL TAKE YOU HOME
IN TEN MINUTES

The new West Liberty Property that your attention is here called to is at present reached in thirty minutes from the Pittsburg Postoffice on the Hill-Top Traction System, via the Mount Lebanon or Old Washington Road. The Grand Plan to be pushed forward includes a great tunnel to pierce the Mount Washington Hill. The line through the tunnel will cut the present line's time schedule from 30 minutes down to 10. Palatial palace cars, like those on the steam railways, will be adopted and run over a flexible track roadway through the tunnel and the property. This remarkable road will be paralleled on either side by a handsome railing fence similar to the English precaution taken to avoid accidents. The high speed at which the cars will be run makes this undertaking a virtual necessity. The improvements which will characterize the operation of the immense traction enterprise will make injury to life impossible than the service now in vogue does.

Gates and stations will be located at the end of each square. No stops will be made between streets. The eyes of the entire world will be upon Pittsburg and this particular project, as we are to have the honor of introducing perhaps the greatest traction innovation that will be effected within the next twenty years.

The splendid new traction line will enter the tunnel directly opposite the Smithfield Street Bridge near the Pittsburg end. Lake Erie Passenger Depot, at Seventeen and Carson Streets, and will come out on the other side of Mount Washington Hill at the Ravine between Paul and Albert Streets, penetrating the Property in less than three minutes after leaving this point.

Even now the traction service to this new Property puts it closer to the city than the East End is. Since the extension of the Hill-Top system over the Washington Road or Mount Lebanon, the building arrives in the vicinity of West Liberty is a surprise to all who have seen the remarkable transformation. What do you think this, the very cream of all the Property out in that forest, will become, when you can reach it from the Pittsburg Postoffice in the finest palace cars in the world on a schedule time of 10 minutes.

Here is some land for investors to digest, the like of which was never unearthed since the great city took on its first boom. The shrewd men who know what this means will be fortunate, indeed. They will be like the first men who got their eye on Squirrel Hill and acted at the right they saw influenced them. In fact, when you hunt up the records of the richest men in any town you will see that they were the first ones to purchase real estate in the right spot. If not, they were the sons or heirs of these first men.

Who Can Say that West Liberty is Not the Right Spot

WEST LIBERTY'S IMPROVEMENTS.

West Liberty will have uniformly graded streets; sidewalks will be laid. Natural gas is already on the property and the Chartiers Water Co. have agreed to run City Water to the Plan this summer.

Building Restrictions will require that all the residences be built back from the sidewalks. Every care will be enlisted to see that the beauty of the thoroughfares is not marred in any particular.

Engineers of ability will assist in working out the plans of this great modern residential city. Churches and schools are even now in close proximity to the property. The famous old "Mt. Lebanon Church is within sight of almost every lot in the plan.

What is most already located there in the way of religious and educational advantages will be brought within easy access by the improved High-Speed Traction Service.

WEST LIBERTY
Free From Smoke, Fog and Dirt.

The striking virtues of West Liberty property are its cleanliness and healthfulness. The lots are all far removed from the great industries of the South Side and Ohio River, and being in direct sweep of the northerly winds they are proof against all smoke, soot, etc. Even were the properties within close range of these great manufacturing plants they would escape all these disagreeable features owing to the winds driving the smoke, etc., in an entirely opposite direction from West Liberty.

TAKE MT. LEBANON HILL-TOP CARS
UNTIL NEW LINE IS COMPLETED.

WEST LIBERTY'S OPPORTUNITY
FOR THE EARLY INVESTORS.

As this sale opens up WEST LIBERTY PLAN OF LOTS No. 1 you will see that investors who purchase now will get in on the ground floor. They will get prices which will be impossible when the second plan goes on. Then think what men will make. Look at the inception of any great project like this, and you can't stand back and wait for others to take your opportunity.

There is no better criterion for you to act upon than the record West End property has made. The only other place in this great city that is as beautiful and close to nature as the East End, is West Liberty.

The only other district in Pittsburg where there are miles suitable for magnificent homes, surrounded by magnificent scenery, is this grand stretch of property to which we now ask your attention.

You can have lawns and grounds as verdant and picturesque as any you will see anywhere else on top of this earth. You can have the same pure air and the happy natural out-door bloom as the wealthiest farmer, who prides himself in the possession of a suburban homestead. But besides all this you will live amidst all the improvements and conveniences to be found in a great and modern city.

Revert again to the wonderful high-speed traction service that is to carry you to and from your office, shop, store or daily duty, in a moment of time that seems almost incredible. You can rise in the clear, unmarred atmosphere of the early morning sunlight at your home, and be lulled by a condition never dreamed possible before, to your place of business or your work bench, almost before you know it. What a pleasure it will be for the tired and weary worker to have business open in the evening and realize that he can reach the luxury of his home in 10 minutes, instead of suffering the additional fatigue that a ride of 35 to 45 minutes inflicts.

THE OBJECT OF THIS GREAT SALE

is to introduce this district and thus eventually be the means of disposing of several hundred acres of adjoining property owned by us. So get here early while the best properties are obtainable. There are only 600 lots in this Ground Floor Plan.

When investors stop to contemplate how fast the property will be sold off they will not hesitate about picking their lots at the earliest possible moment.

Look at how the hill districts are built up. Look at how the South Side is moaning and gasping for more room, swallowed in heavy clouds of smoke and often in densest fogs.

When you sum up these conditions, can you not see a fortune in this fresh air district surrounded by all the beauty that nature has bequeathed you? Contrast your opportunity with what is offered by the adjoining properties.

The lots that are offered to-day at a marvelous figure to start the first boom on West Liberty property, will soon up before the host of the summer sun visits us, to two and three times the figures advertised to-day.

Men who pay $200 and $300 for their lots will be refusing that many thousands in less than two years.

THE RESPONSIBILITY
—OF—
The Beechwood Improvement Company, Ltd.

is unquestionable. We have sold since 1898 Thirteen different Plans, containing over 5000 lots. The success we have had in selling and re-selling to old customers is positive, irrefutable evidence that our statements are always lived up to and more than verified in the Property. We respectfully refer you to any of our patrons as to our splendid treatment of them, both with regard to sickness and in all questions pertaining to the business dealings with us.

Another commendable feature we might mention is that all our patrons have made money in these transactions. Especially was this the case at South Sharon, where in most instances the purchasers more than doubled their money in less than one year. Indications point to a repetition at the South Sharon money-making possibilities at West Liberty, in fact even greater and more thrilling results for investors are guaranteed.

SEE THE BEECHWOOD IMPROVEMENT CO. LIMITED.
TIMES BUILDING —OR— OFFICE ON PROPERTY

This vision for modern life was created by the multi-pronged enterprise of Booth and Flinn. Road builders since 1893, they constructed the 3,500-foot-long Mt. Washington Tunnel and the Beechview streetcar line. Pennsylvania state senator William Flinn, of the aforementioned contracting firm, had earlier teamed with Peter Shields and others to purchase hilltop farmland with an eye to this future. This large (three-by-four-foot) c. 1902 advertisement offers the first of these lots for sale. Five lot plans were ultimately developed. (Courtesy Historical Society of Western Pennsylvania.)

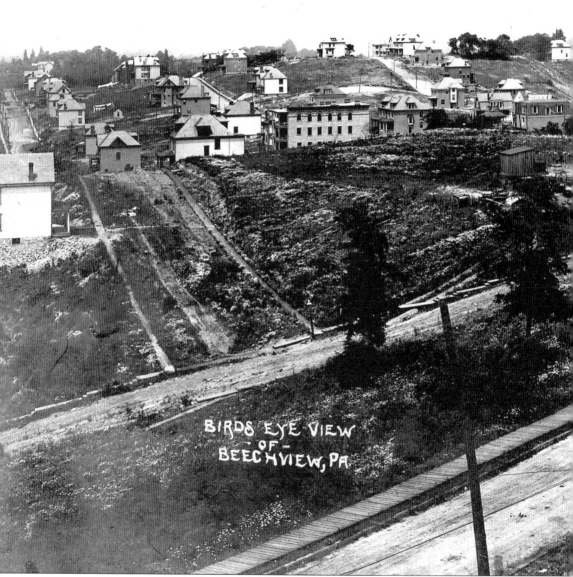

BIRDS EYE VIEW
- OF -
BEECHVIEW, PA

This *c.* 1905 postcard captures a view from Broadway Avenue toward the northeast. The trolley is near the intersection with Coast Avenue, and a newly built Boylan Building stands on the corner at far right. In the background, parallel roads stretch out in a northward direction; the numbered streets Six through Nine became Methyl, Beechview, Fallowfield, and Dagmar. The crossroad in the distance at right is Sebring at Alton. Rubble between the track and roadbed

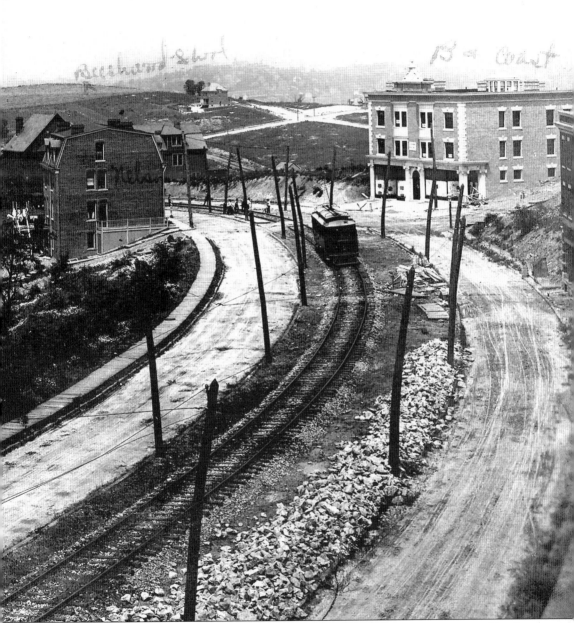

on Broadway provides evidence of recent work. Access to these hilltops was guaranteed by the construction of the Mt. Washington Tunnel and the laying of the street railway tracks connecting Pittsburgh with the South Hills. Although real-estate development did not progress as rapidly as planned by the owners of the Beechwood Improvement Company, few will dispute the ultimate benefits of their grand design. (Courtesy Barbara Haggerty.)

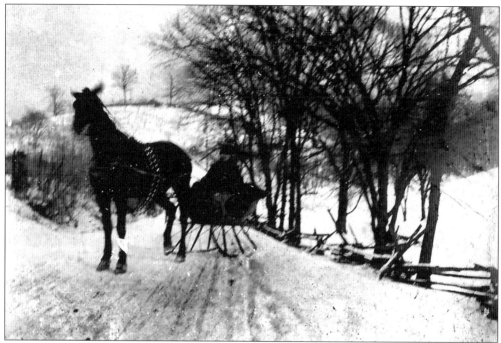

A horse-drawn sleigh glides past fenced farm fields in a hilly wintertime landscape characteristic of Beechview before development. This image captures the essence of expedient transportation, even at the close of the 19th century. (Courtesy Donald P. Neeld.)

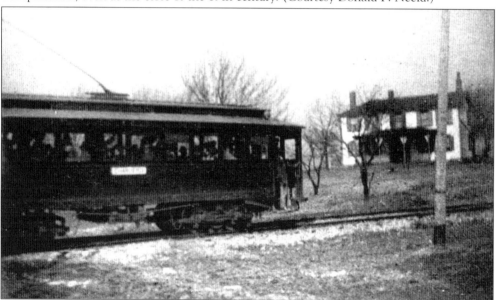

A sign of change on the ridge was the arrival of the streetcar. This inbound Pittsburgh/Charleroi inter-urban passes the John R. Neeld (1824–1896) residence. Established in 1900, this line had run on the West Liberty Avenue track, but utilized the Beechview route from 1904 to 1909. These cars made no stops between Castle Shannon and downtown Pittsburgh. Double-ended cars such as this could travel on a single track; the conductor physically swung the overhead pole around and changed ends to redirect. (Courtesy Donald P. Neeld.)

Canton Street, connecting Coast with Hampshire, was originally called First Avenue. As it happens, this short street ranks as Pittsburgh's steepest, with a grade of 37 percent. Still paved in the Belgian block that lies beneath most area streets since resurfacing with asphalt began in the 1970s, Canton seems a lightly traveled road, and for good reason: It is a one-way street, heading uphill, and is best avoided under inclement conditions. (Courtesy Anna Loney.)

City steps, first indicated on insurance maps in 1884, still figure prominently when navigating Pittsburgh. Beechview holds 39 of 712 total sets. The steps were originally constructed of wood, but they deteriorated rapidly and were sometimes ravaged for firewood. These steps line Boustead Street, the city's third-steepest road. (Courtesy Anna Loney.)

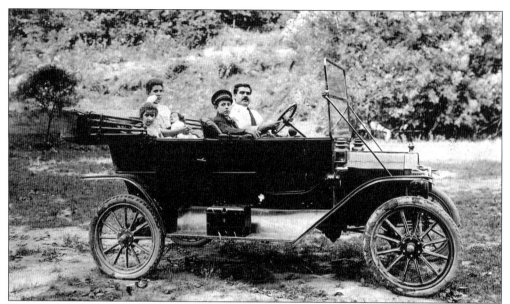

The automobile was a symbol of success and freedom. Here, the family of Thomas Arrigo, a local grocer, poses in a new vehicle at Hutchie's farm, adjacent to Crane Avenue, around 1915. Tom and son Lawrence sit in the front, while Tom's wife and their daughters, Mary and Josephine, sit in the back seat. (Courtesy Jackie Heidenreich.)

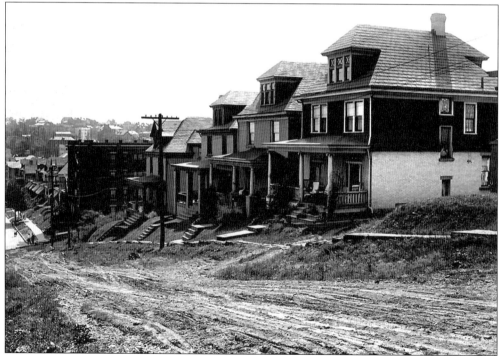

Fallowfield Avenue, seen heavily built with homes in the early 1900s, has been graded and readied for paving. Surveyors stand at the bottom of the hill, near the intersection of Sebring Avenue. At 22 percent grade, Fallowfield is yet another that ranks on the steep streets list. (Courtesy Pittsburgh City Photographer Collection, University of Pittsburgh.)

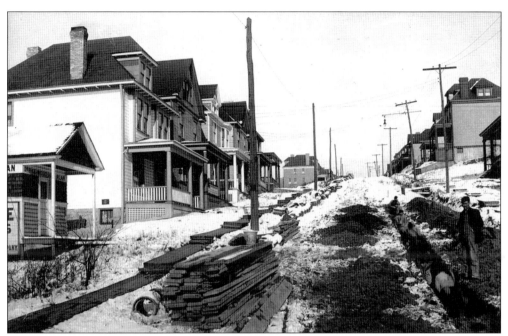

Here is steep and snowy Kenberma Avenue on December 5, 1911. This photograph of road construction documents workers hand-digging a utility trench in the middle of an unpaved street. (Courtesy Pittsburgh City Photographer Collection, University of Pittsburgh.)

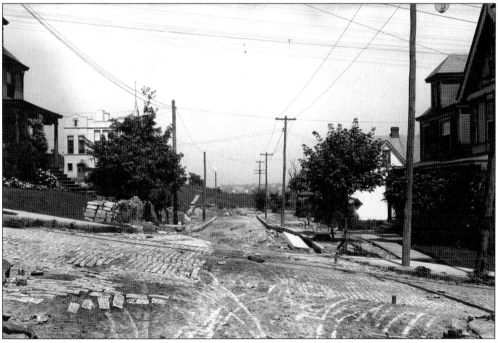

This view, looking north on Rockland Avenue from Sebring, the cross street, shows a bit of Beechwood School on the left. The way is ready for road paving and the installation of sidewalks that will carry generations of children to school. (Courtesy Pittsburgh City Photographer Collection, University of Pittsburgh.)

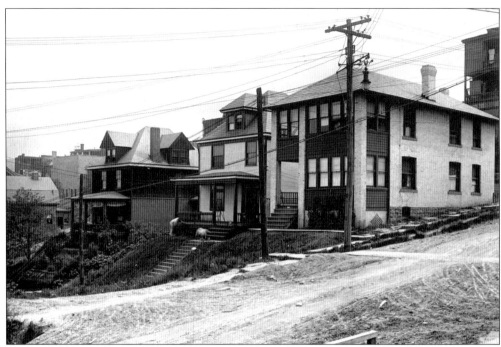

On June 2, 1919, the crossroads of Methyl and Hampshire were still unpaved. This is the view from the Beechview Methodist Church. (Courtesy Pittsburgh City Photographer Collection, University of Pittsburgh.)

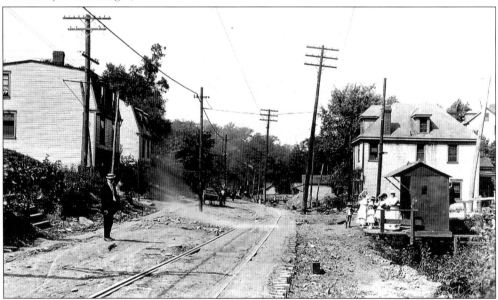

In Pittsburgh, street railways were horse drawn in their earliest incarnation, around 1860. December 1888 marked the beginning of the Central Traction Company and its cable car service in downtown proper. The first electric-car lines date from about 1890. Ten years later, tracks made their way along this valley, West Liberty Avenue, a corridor to the town of Washington in the south. This 1915 view looks northward along West Liberty at Curran Hill Road. (Courtesy Carnegie Library of Pittsburgh.)

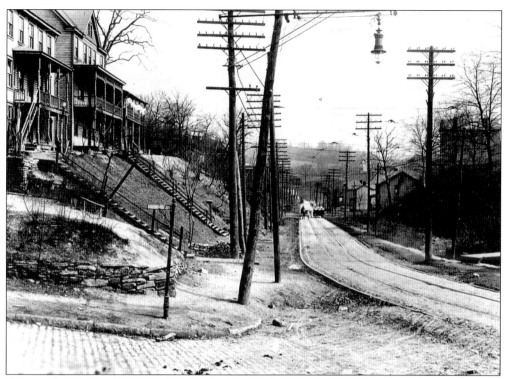

Street railways like this one at Brookside Avenue developed alongside electric light and power companies. An electric-arc street lamp hangs from a telegraph pole above this West Liberty Avenue intersection in 1915. (Courtesy Carnegie Library of Pittsburgh.)

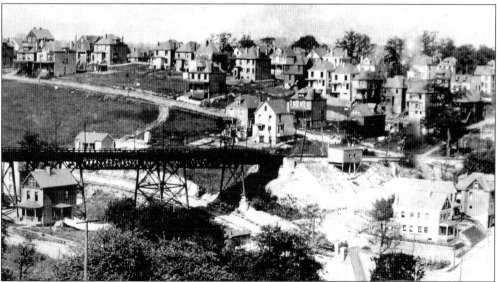

Even today, the Cape May Viaduct carries streetcars above the road from which its name derives. In this early-1900s photograph, the intersection of Cape May and Hampshire is visible in the lower right. The parallel hillside streets of Alton, Rockland, Westfield, and Orangewood were gradually being blanketed in homes during this period. (Courtesy Miller Library, Pennsylvania Trolley Museum.)

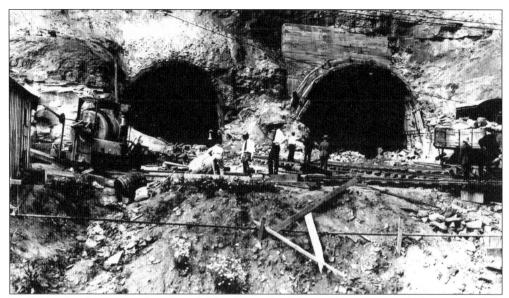

In 1924, after five years of work and $6 million, the Liberty Tunnels provided an automobile corridor more than 5,800 feet through Mt. Washington, from the Liberty Bridge to Beechview's "doorstep" at West Liberty Avenue. Contractors Booth and Flinn realized this project, which was popularly called "the Tubes." This is an external view of the construction. (Courtesy Carnegie Library of Pittsburgh.)

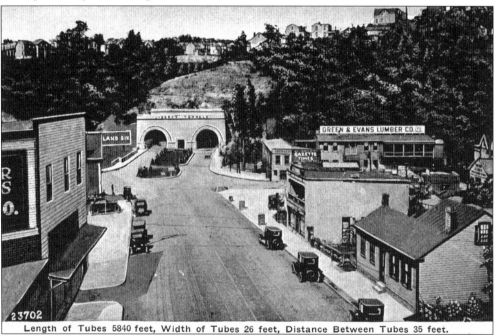

Length of Tubes 5840 feet, Width of Tubes 26 feet, Distance Between Tubes 35 feet.

Almos Davidson Neeld, son of Beechview's George Neeld and grandson of Eli Neeld, was consulting engineer in the design and construction of the tunnels. Temporary rail lines facilitated the work. After teams bore through rock from both ends, the tunnels met and were only three-eighths of an inch off center. This early postcard shows the south end of the newly completed Liberty Tunnels. (Courtesy Paul Dudjak.)

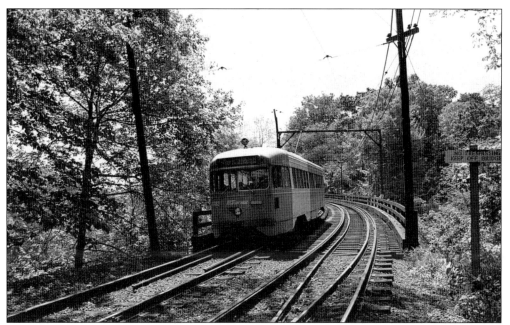

Streamlined Presidential Conference Cars (PCCs) began service in 1940. The acme of streetcar service in many North American cities, these cars were in wide use until the 1980s in Pittsburgh. Here, the familiar 42/38 traverses the bridge above Brookside Avenue's wooded slopes on May 25, 1981. (Courtesy Pittsburgh History & Landmarks Foundation.)

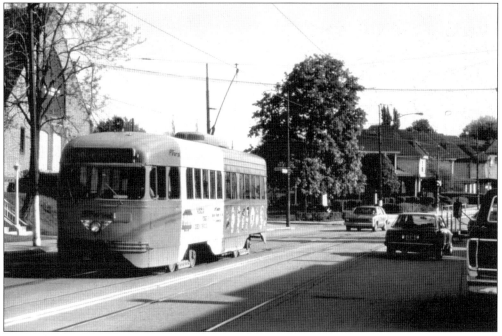

Colorful Ad Cars operated from about 1973 to 1987. This one, inbound at Shiras in 1983, advertises Pittsburgh's locally produced *Mister Rogers' Neighborhood.* Just as the trolley still traverses the famous "television neighborhood," so too is Beechview still served by faithful rail transit. (Courtesy George Gula.)

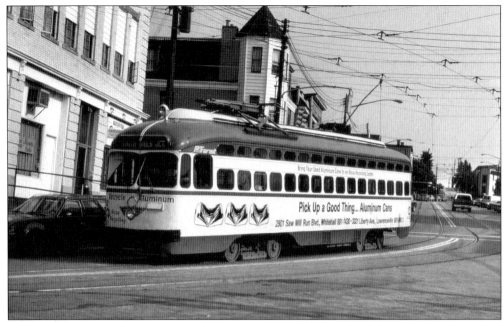

This PCC promotes aluminum recycling as it rounds the bend on Broadway at Hampshire Avenue. Trolleys share the road with automobile traffic along a one-mile stretch through Beechview. (Courtesy George Gula.)

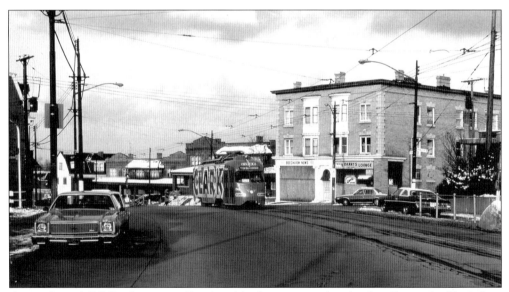

An outbound PCC advertising Pittsburgh's favorite candy, the locally made Clark bar, passes the Boylan Building at Coast and Broadway in 1984. PCCs once numbered a fleet of 600. They were used exclusively until 1984, when the South Hills system reconstruction began, and operated in some areas of Pittsburgh until 1999. Beechview abandoned PCCs because the heavily built cars were so difficult to push out of the way when they broke down. (Courtesy George Gula.)

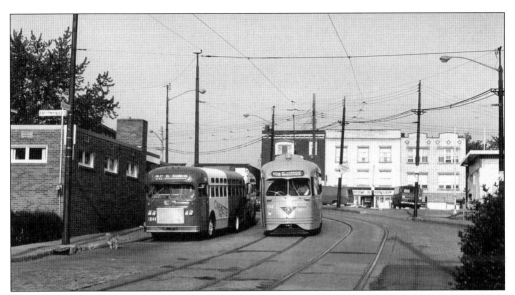

The Shadycrest bus awaits transferring passengers near the Fallowfield stop in 1980. With post–World War II building development at the north end of the community and with many people completely dependent on public transportation, this bus spur began on November 24, 1947; it lasted until the mid-1980s. Ironically, a 1910 study of future commuter needs by Frederick Law Olmsted proposed rail development that would have served this north end of Beechview. (Courtesy George Gula.)

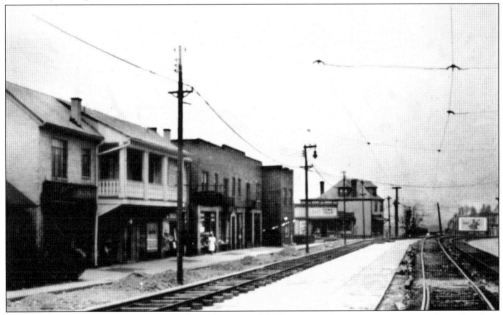

Road and track construction on Broadway in 1940 required a temporary set of tracks that were laid atop the left side of the street. At that time, the central unpaved right-of-way on which trolleys ran became city property. The two sets of tracks were laid into an entirely paved roadbed. Public-transit users and automobile drivers alike came to know the island car stops that punctuate the avenue. This view takes in the west side of Broadway, looking toward Boustead. (Courtesy George Gula.)

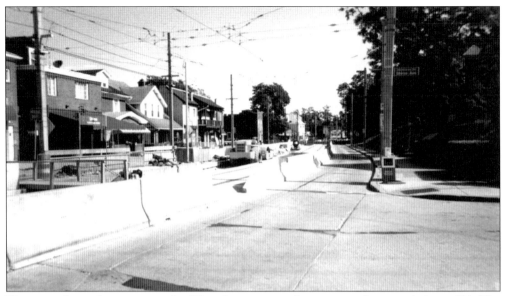

This view shows the same stretch of Broadway seen in the previous photograph (page 23). The track reconstruction project undertaken between 1984 and 1987 did not include provision of temporary rail service; instead, buses were substituted for the streetcars. Substantial closures, barricading, and ongoing work created woes for commuters, residents, and especially businesses. (Courtesy John Cvetic.)

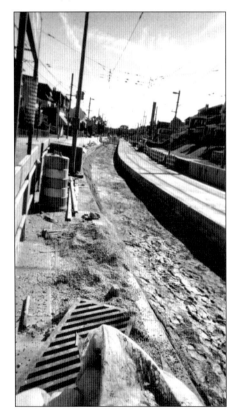

This photograph provides further evidence of the massive reconstruction that disrupted life along Broadway Avenue in the 1980s. (Courtesy John Cvetic.)

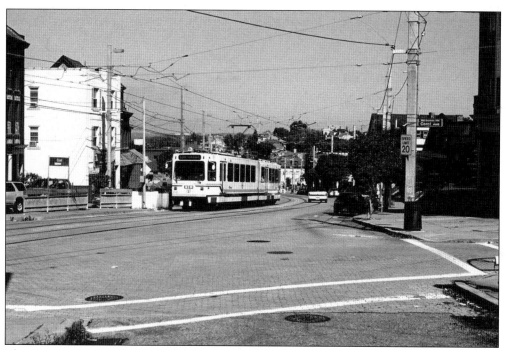

The Port Authority of Allegheny County (PAT), which now controls the South Hills LRV system commonly called the "T," was formed in 1956. Its mission was to develop port facilities in the city. In 1964, PAT took charge of the Pittsburgh Railways Company by power of eminent domain. By 1966, only Pittsburgh's South Hills was serviced by streetcars. (Courtesy George Gula.)

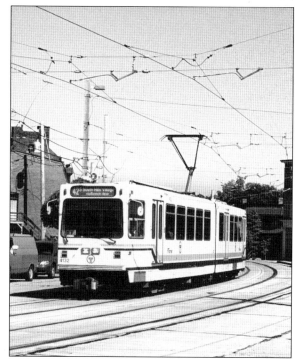

In 1980 groundbreaking took place for today's T, linking a downtown subway with the South Hills Village Mall seven miles to the south. Thousands of commuters use this effective form of transportation, as they have for decades, passing through Beechview daily. (Courtesy George Gula.)

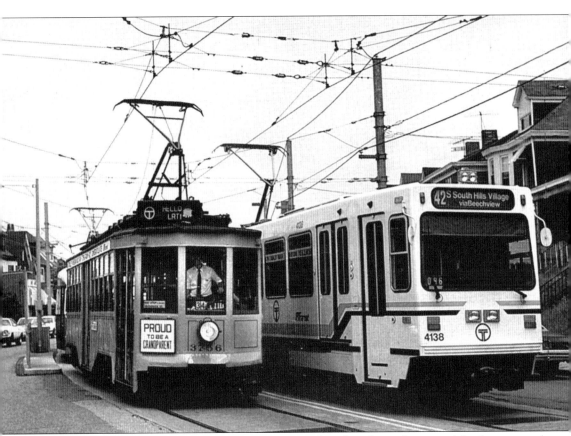

Old meets new as this "chrome orange" 1920s-era, low-floor Jones (so named for designer and Pittsburgh Railways superintendent P. N. Jones) passes a modern light-rail vehicle (LRV) during the post-reconstruction opening of Broadway's tracks in 1986. LRVs were made by Adtranz/Duewag. Adtranz is successor to Pittsburgh's Westinghouse Corporation. (Courtesy Harold M. Englund.)

Two
FOUNDERS AND FAMILIES

Robert Snodgrass (1758–1796) came to Allegheny County from Lancaster County in 1779. He purchased land that was eventually deeded in 1794, parts of which became Beechview. Of Snodgrass, the 1889 *History of Allegheny County, Pennsylvania* states the following:

> After having cleared a small space and erected a rude log cabin he returned to visit the home of his childhood, where Sept. 12, 1780, he married Miss Jean White. In company with his newly chosen companion he now turned his face toward his log cabin in the forest across the mountains. His attitude toward the Indians was that of brother toward brother. The Indians ate at his table, and brought him game from the forest, small baskets and trinkets of their own handiwork: they smoked the pipe of peace, and he thus secured for himself and family safety from the tomahawk and scalping-knife, and many other advantages.

This biography goes on to mention descendants owning parts of the original tract: Mrs. Bulford, Mrs. Simmons, Mrs. Hubbard, and M. E. Crane, grandchildren; and H. J. Milholland, great-grandson. These names are present in the 1886 *Atlas of the Vicinity of the Cities Pittsburgh and Allegheny, Penna.* in parts of Union Township and West Liberty Borough. Other early maps list these family names: Algeo, Curran, Foster, Lowen, Haberman, House, Neeld, Wilson, Collins, and Allen.

With the opening of the trolley line in 1904, settlement expanded. In the spring of 1905, Allegheny County formally recognized the petition for incorporation of the borough of Beechview. The first Beechview Borough Council meeting was held on August 31, 1905, at the home of George N. Hobson, at Seventh and Trenton (now 1400 Beechview at Bayonne). Issues discussed and noted in these and subsequent council minutes included bonds, taxation, gas streetlights, water, sewage, garbage, streets, sidewalks, fire and police, and even the matter of a dog pound and net.

Within three years, things were changing. The switch from gas to electric lighting became an issue, and by 1908, the public was petitioning to become part of the city of Pittsburgh. The decision to rename Beechview streets in 1908—so as not to duplicate Pittsburgh's streets—provides evidence of a willingness to pursue annexation, which perhaps had come to be seen as inevitable.

In the meantime, nothing stopped the ongoing settlement by diverse people with a common interest in realizing the American dream. Italians, Jews, Irish, Germans, Swedes, and Eastern Europeans continued to purchase homes and raise families in Beechview.

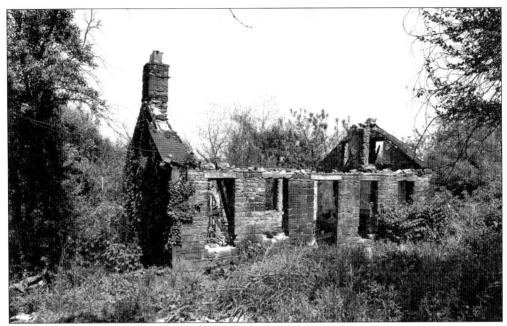

Researchers from the Pittsburgh History & Landmarks Foundation toured Beechview, recording information and taking photographs, on May 25, 1981. Pictured here are the collapsed remains of a *c.* 1825 farmhouse that stood on the hillside below Westfield Street. Most recently occupied by the Lau family, the property was previously owned by Peter Haberman and, before that, by Caleb Foster. Other historic homes documented during the researchers' tour that day include the Lowen-Shaffer House and the Algeo Farmstead. (Courtesy Pittsburgh History & Landmarks Foundation.)

This 1794 document is the deed that the Penn family gave to Robert Snodgrass for his purchase of approximately 453 acres of land south of Coal Hill (Mt. Washington). The north end of Beechview was derived from that land. (Courtesy Daniel Bulford.)

John Bulford (1814–1880) married
Sarah Snodgrass (1819–1899) in 1838,
and together they had 13 children.
The Bulford Farm's 14 acres was
maintained by their grandson Walter
as a working farm and riding stable
well into the 20th century. (Courtesy
Daniel Bulford.)

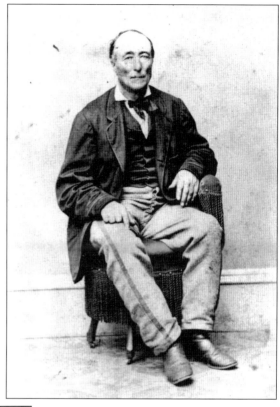

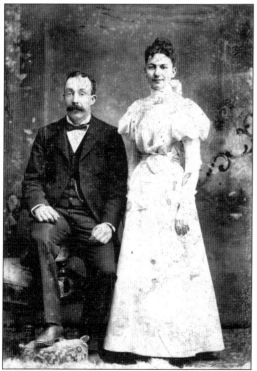

Robert Bulford (1868–1924), son of John
Bulford, married Carrie A. Kennedy
(1874–1958) in 1897. In 1905, when
Beechview incorporated as a borough,
Robert and other members of the Bulford
family, along with the neighboring
McGuires, the Reeses, and the
Goodspeeds, requested exemption of their
land from this effort. Presumably
generations of farming had served them
well and they hoped to continue.
(Courtesy Daniel Bulford.)

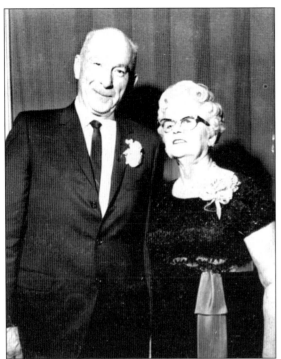

Walter Kennedy Bulford (1905–1966) is shown with his wife, Eleanor McConkey Bulford. Walter was one of five children and Robert's only son. Walter's son Dan was noted in a late-1940s newspaper article for riding the streets of Beechview on horseback with neighborhood friends. Dan also recounts taking a horse-drawn sleigh as far as Dormont, a nearby community, in his youth. (Courtesy Barbara Bulford Paoletti.)

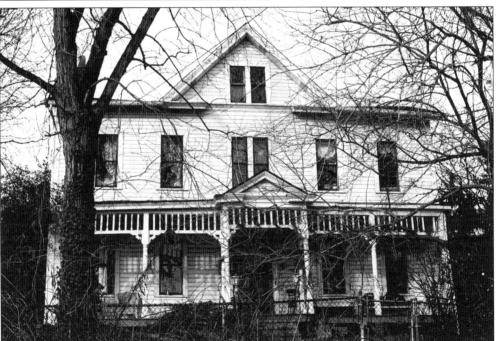

The Algeo home is a two-and-a-half-story 1890s frame farmhouse on Fair Acres Avenue, above and facing West Liberty Avenue. The original 14-acre tract and home date from Thomas Algeo's purchase of land in 1847. Thomas Algeo was born in Pittsburgh, the son of successful merchants John and Anna Bell Algeo. Thomas married Mary Walker in 1844, and they had 10 children. (Courtesy Anna Loney.)

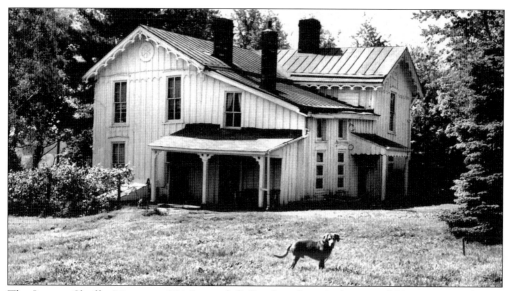

The Lowen-Shaffer House, at 311 Lowenhill Road, is described as a mid-Victorian Carpenter Gothic structure. Situated just north of Crane Avenue, it was designated a historic city structure in 1992, after a battle to save the home from demolition. John Lowen, its builder, gardened and grew fruit trees on 50 acres, after he retired from city service as a gas pipe fitter. He died here at age 78 in 1885. Pear trees descended from his orchard still stood late into the 20th century. (Courtesy Joseph Shaffer.)

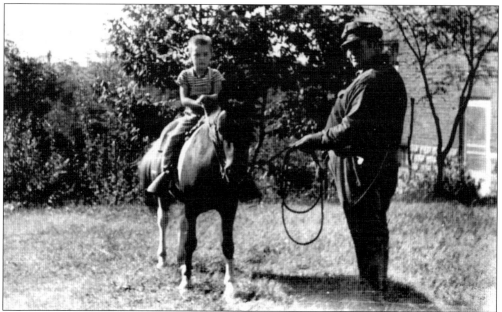

Harry Shaffer (1903–1965) holds the reins for his son Joseph in 1944. Harry, his wife Josephine (1905-1989), and their three children actively farmed the property from 1935–1965; they actually purchased the Lowen Farm in 1940. It was one of the city's last for-profit vegetable and fruit truck farms. In the 1990s, the house was threatened with demolition. Since its 1997 purchase by Tom and Chris Simmons, the Lowen-Shaffer House is actively being restored. (Courtesy Joseph Shaffer.)

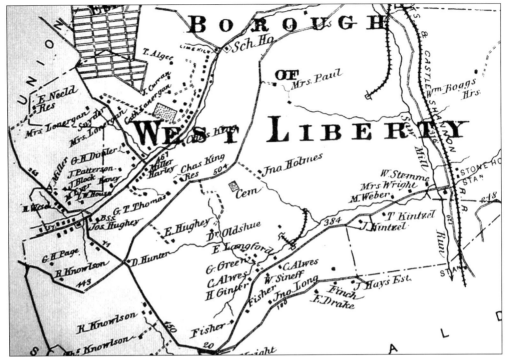

John R. Neeld (1824–1896) bought land from his father, Eli, at the south end of what would be Beechview. Eli, originally of Philadelphia, had been a stagecoach driver between home and Pittsburgh. He married Mary Jane Martin and they had three sons—John R., George, and James. Eli's estate stretched from the crest of Beechview down the eastern and western slopes of the hill, and would become home to George and John R. This 1876 *Atlas of the County of Allegheny, Penna.* shows the location of Eli's residence. (Courtesy Historical Society of Western Pennsylvania.)

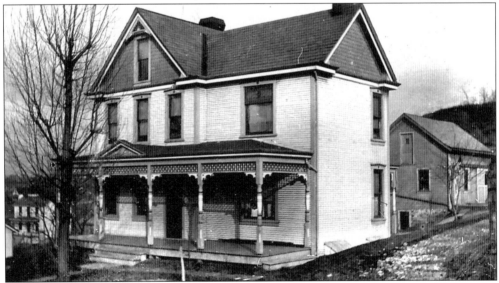

The home of Lewis Neeld (1869–1955), son of John R., still stands at Wenzell and Boustead Avenues. Lewis earned a degree in electrical engineering from Western University, which is now the University of Pittsburgh. (Courtesy Donald P. Neeld.)

As a young man, John R. Neeld was a mate on steamers plying the Ohio and Mississippi Rivers. With the outbreak of the Civil War, he was made captain of the dispatch boat *DeSoto* and later chief executive officer of the gunboat *Lafayette*. During the war and between boat assignments, he managed naval stores at Memphis. (Courtesy Donald P. Neeld.)

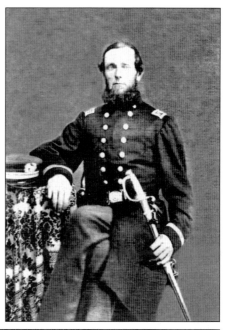

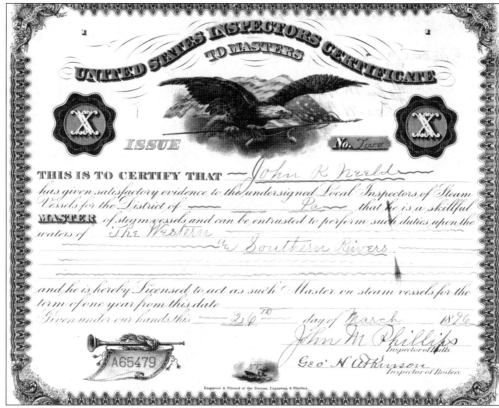

In 1872, Capt. John R. Neeld returned permanently to Pittsburgh to become the local inspector of hulls, a position he actively held until his death. This 1896 certificate, issued in the last year of Neeld's life, grants him master-inspector's status. (Courtesy Donald P. Neeld.)

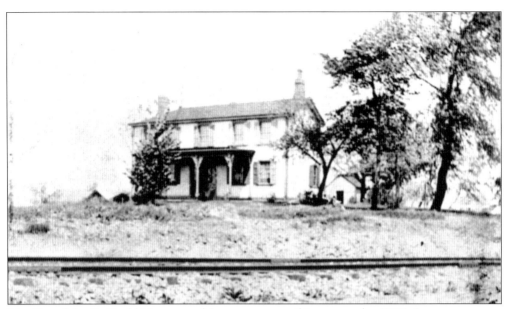

The Capt. John R. Neeld House stood for a century until it was razed *c.* 1957. Apartments were built on the site. The single track of the 1904 streetcar passed in front of the house, heralding things to come as the farmstead transformed to suburban home. Eleanor Jane Smith (1868–1955) married Lewis Neeld in 1898. She lived out her days in the Neeld Homestead on Broadway. (Courtesy Donald P. Neeld.)

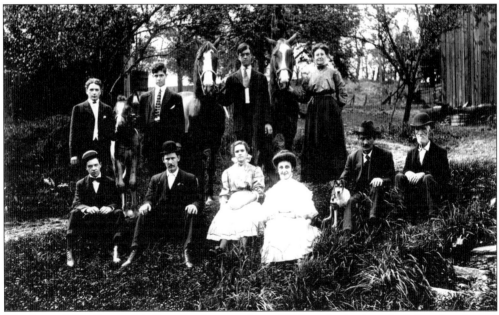

Members of the George M. Kerr family pose about 1905 in the backyard of their fine home, built on the northwest corner of Wenzell and West Liberty Avenues. George pursued a successful career as a farrier and blacksmith. Pictured from left to right are the following: (first row) two unidentified men, Ruth Kerr, Edna Kerr, George M., and James Kerr (George's father); (second row) unidentified, Howard Kerr, Frank Kerr, and Emma Sharlow Kerr (George's wife). George died on August 18, 1931. (Courtesy of George H. Kerr.)

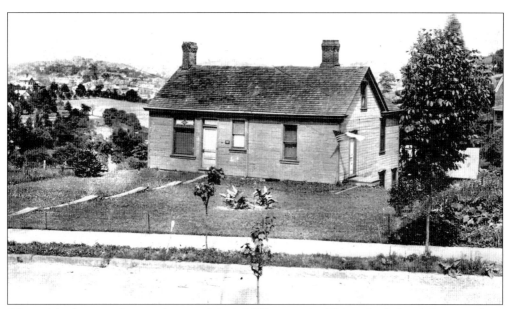

When this photograph was taken, on July 4, 1908, several additions had already been made to the small post-and-beam structure at the core of this home at 1317 Beechview Avenue. It was originally a farmhouse that stood at the center of a much larger plot of land owned in 1876 by J. H. Mulholland. The property's owner in 1908 was carpenter Alex Sykes of Washington, Pennsylvania. The home was situated on two city lots purchased from the Beechwood Improvement Company in 1907. (Courtesy Anna Loney.)

If the past resided at 1317 (above), the future was being designed for H. A. Otto across the street, at 1318 Beechview Avenue, around 1911. Of wood-frame construction with brick veneer, this three-story home with a large front porch is characteristic of the preponderance of Beechview homes. Otto, an inventor, had an upstairs bedroom specially fitted for use as a laboratory, complete with gas burners. (Courtesy Nicholas Cindrich.)

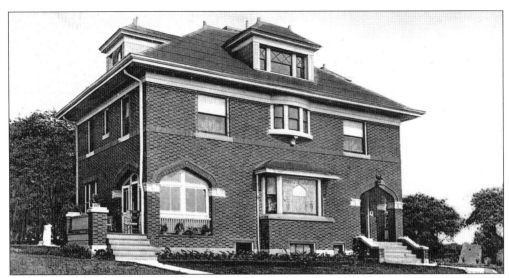

Thomas A. McQuaide (1860–1925) built this stately home at 961 Gladys Avenue in 1910. This photograph of the home was published as a postcard. Located between the Lowen and Bulford Farms, this area was not included in Beechwood Improvement Company land and, perhaps for this reason, was called Beechview Heights. (Courtesy Paul Dudjak.)

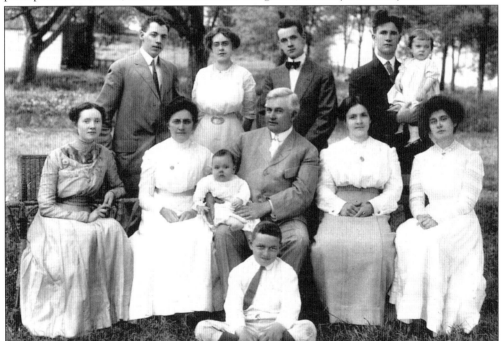

Thomas A. McQuaide, the first Pittsburgh superintendent of police, retired from service to run a private detective agency. Here, he and wife Annie Claire McQuaide (1861–1938) sit for a portrait with other family members about 1910. From left to right are the following: (first row) Henry McQuaide; (second row) Marie McQuaide, Annie Claire, Thomas A. with baby Thomas, Eleanor Joyce McQuaide (wife of Franklin), and Claire McQuaide; (third row) John Joyce, Margaret Joyce (John's wife), Thomas McQuaide Jr., and Franklin McQuaide holding baby Eleanor. (Courtesy Chelsea Hammond.)

Anthony and Catherine LaRusso Gaetano came from Italy when their eldest son, Vincent, was a baby. They settled in a South Side neighborhood, and Anthony worked as a laborer for the city. He later purchased a home and moved the family to 1599 Fallowfield Avenue. Gaetano family members pictured c. 1918 are, from left to right, as follows: (first row) Catherine, Caroline, Ralph, Rose, Anthony, and baby Angeline; (second row) ? LaRusso (Catherine's brother), Mary, Josephine, and Vincent. (Courtesy Joan Mascaro Gaetano.)

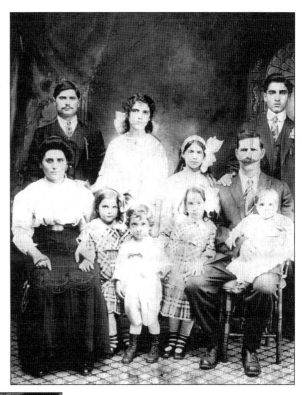

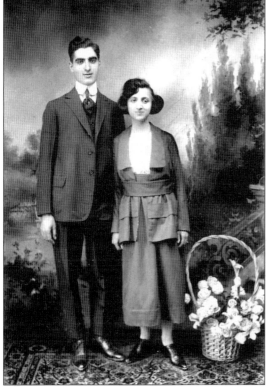

Vincent Gaetano married Mary Calabrese in 1920. The young couple purchased a home in Beechview on Realty Avenue. For more than 50 years, Vincent worked as a barber in downtown Pittsburgh, across from the Stanley Theater (now the Benedum Center). The Calabrese family was from Greenfield. Mary's sisters— Teresa, Madeline, Rose, and Rae—and their families eventually moved to Beechview as well. (Courtesy Joan Mascaro Gaetano.)

The Enlow House, at 944 Gladys Avenue, appears on a snowy day in the early 1970s. Named for sisters Alice and Marguerite Enlow, who lived out their days here, the residence stands not far from the Lowen-Shaffer Home. However, this was not always the case: the home was moved to this hilltop locale from the George Lowen Farmstead early in the 1900s. (Courtesy Larry Pollastrini.)

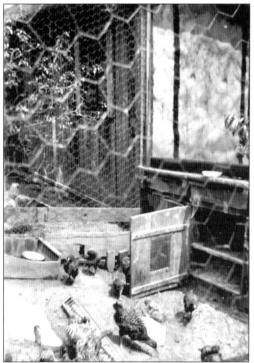

Backyard chicken coops, like this one at the Mascaro residence at 276 Sebring, were common in the 1930s. This effort surely helped ease Depression-era privations. Although raising fowl and livestock in this residential area would be impractical—even illegal—today, grape arbors and gardens still abound in the neighborhood. (Courtesy Joan Mascaro Gaetano.)

Born in Italy, Pierina and Adolph DeGasperi lived in Pittsburgh's Hill District before buying this home at 226 Sebring Avenue in 1916. A young Adam DeGasperi stands on the front steps. His parents worked in downtown Pittsburgh, and commuted by streetcar. The family never owned, nor needed to own, an automobile. Pierina worked as a seamstress, doing alterations for men's stores. Adolph was a waiter at a downtown supper club called Nixon's. (Courtesy Virginia DeGasperi Noceti.)

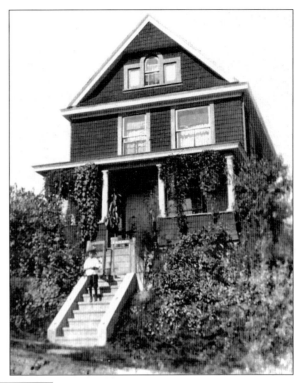

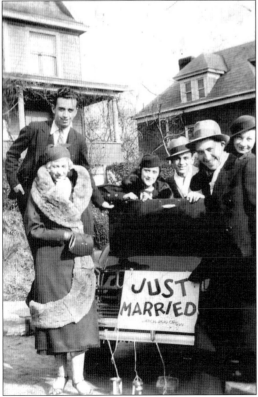

Adam DeGasperi and his bride, Helen Ensslin, sit in the rumble seat at center. Adam was a musician with popular dance bands such as Baron Elliot, Brad Hunt, and Lee Kelton. Louis DeGasperi and Meta Ensslin stand to the left of the automobile, and Henry Ensslin and Peggy Hart are to the right. The sign was lettered by Johnny Hart, a commercial artist. (Courtesy Virginia DeGasperi Noceti.)

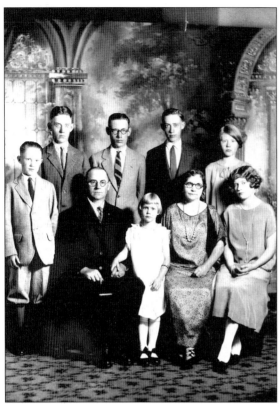

The Johnson family poses c. 1920. From left to right are the following: (seated) father Elmer (1875–1940), Margaret, mother Ida (1874–1953), and Ida; (standing) Elmer, Edward, Harold, Carl, and May. All the children were born at 2121 Vodeli Street, except Harold, the eldest, born in 1903. The elder Elmer and Ida were Swedish immigrants, and they married on August 29, 1902, at the McKeesport home of Ida's sister. Elmer built many of the homes in Beechview and Dormont, including his own. (Courtesy Janet Felmeth.)

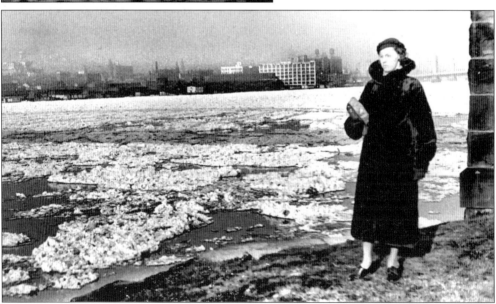

Minnie Meyer was photographed on the banks of the Allegheny River by her husband, Arthur, as flood waters receded in 1936. Days before, with disaster looming, Arthur had rented second-floor office space and hired laborers to move his business, Fountain Pen Service, out of its street-level storefront on Fourth Avenue. In the absence of trolley service, Arthur walked home to 1412 Rutherford Avenue, taking photographs along the way. (Courtesy Betty Meyer Dillon.)

Dennis F. Dwyer (d. 1948) was born in Ireland. His wife, Emma G. Cox (d. 1981), was from Lawrenceville in Pittsburgh. They made their home first on Dagmar Avenue, and then on Broadway. Dennis, a police officer, represents a proud segment of city service workers who for generations have chosen to make their homes in Beechview. This portrait was taken in the 1920s. (Courtesy Bob Mock.)

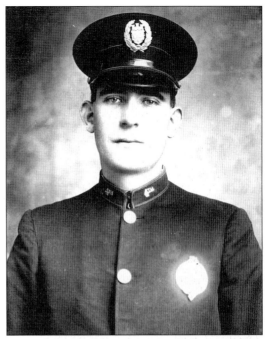

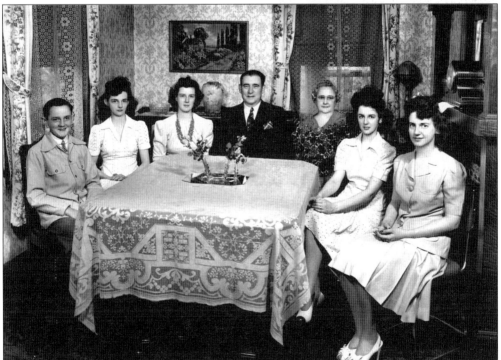

Gathered in the dining room of their Broadway home in the 1940s are, from left to right, James, Dorothy, Julia, Dennis, Emma, Winifred, and Mary Dwyer. From the age of 18 until her 1958 marriage, Winifred Emma Dwyer Mock (1919–2003) ran a Broadway Avenue beauty shop with the aid of her sister Mary. The Dwyer home, adjacent to St. Catherine's Church, was recently torn down. (Courtesy Bob Mock.)

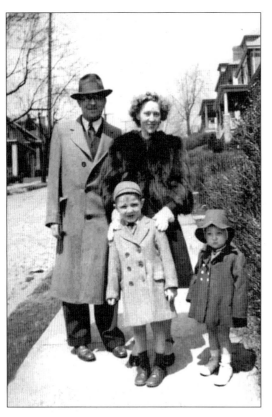

Philip Hrabar, wife Julia June Dudish Hrabar, and their children, Philip Jr. and Lois, stand in front of the home they rented on Alton Street in the 1940s. Philip worked as financial secretary-treasurer for the United Russian Orthodox Brotherhood of America, a fraternal insurance company. Julia June, busy with Beechwood School's Parent Teacher Association, also served as Republican committeewoman for the district. (Courtesy Lois Hrabar Liberman.)

The Hrabars purchased this 1416 Beechview Avenue residence in 1944. Having survived the Johnstown flood as a youth and escaped the 1936 downtown Pittsburgh flood by rowboat, Philip was heartened to buy property on high and dry ground. When Philip died suddenly in 1957, Julia sought and found employment to support her family. She passed away in January 2005 at age 92. (Courtesy Lois Hrabar Liberman.)

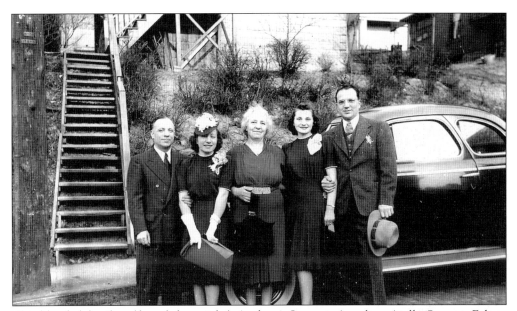

This blended family—(from left to right) Anthony Sunseri, Angelina Aiello-Sunseri, Felicia Aiello, Amelia Aiello-Ellenberger, and Harry Ellenberger—gathers in front of the family automobile, parked in the street, in the 1940s. Note the steps that rise steeply from the curbside to the front door. (Courtesy Cara Jones.)

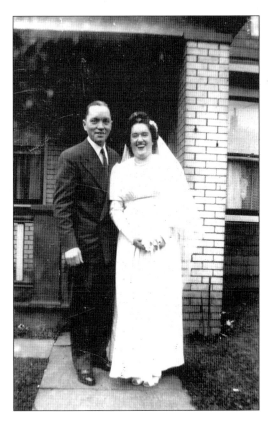

Married at St. Catherine's Church on February 14, 1946, William Thomas Hammill (1913–1979) and Sara Marie Maroney (1919–1986) stand outside their 1334 Methyl Street home. William, a 1932 graduate of Westinghouse High School, worked as a state liquor store manager until his retirement in 1973. Sara, a working mother of three, was a Bell Telephone operator until about 1974. She graduated from South Hills High School in 1937. (Courtesy Roberta Hammill Saunier.)

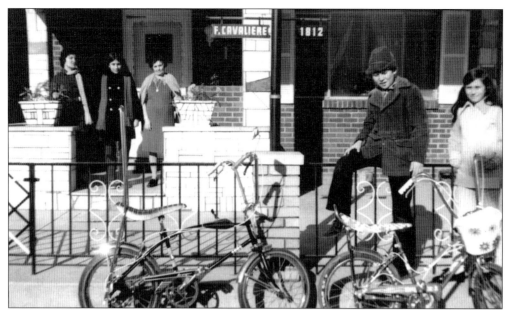

The Cavaliere-Pasquale family, like so many others in Beechview, traces its roots to Italy. Here, three generations are pictured in the front yard of the Cavalieres' Broadway residence about 1970. From left to right are Angela Pasquale, Phyllis Pasquale, Rosa Cavaliere, Angelo Pasquale, and Rose Pasquale. (Courtesy Angela Cavaliere Pasquale.)

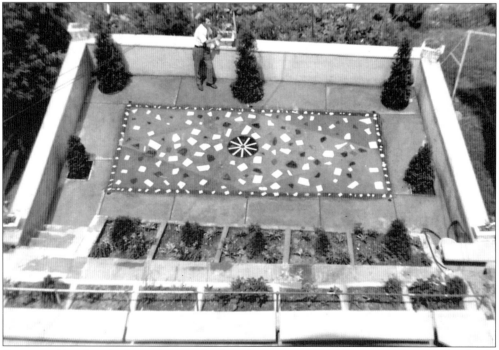

Fortunato Cavaliere looks out from his backyard terrace in 1971. The terrace features the family patriarch's masonry work and sense of style. The symbol of Fortunato's Italian oven-making skills—a built-in, wood-fired bread oven—was at hand for making pizza and other specialties. (Courtesy Angela Cavaliere Pasquale.)

Three
MEMORIES OF CHILDHOOD

What are the memories of a childhood lived on the ridge?

Beechview provided a degree of economic stability, safety, and friendly neighbors. Children grew up with grandparents and cousins living in the same house or on the same block. Those of all ethnic backgrounds played together. Sidewalks were a safe zone for running, hopscotch, roller-skating, and skateboarding. The backyards of Beechview featured vegetable gardens, grape arbors, wooden beehives, goats, and chicken coops. These were the elements that shaped young lives.

A former resident who moved to Methyl Street (Sixth) in 1903 as a child remembers the trolley whistles, the mud, the darkness, and the ringing of hammer and saw as new houses sprang up over the hillsides. One Sebring Avenue resident recalls backyard plays performed in the 1930s in front of a bedspread stretched over a clothesline and the homemade costumes constructed of crepe paper. The boys of Sebring erected a wooden "rolley" coaster in the Giandemenicos' backyard at 244 Sebring. One resident remembers lying in bed late at night in her Crosby Street home in the 1940s and reading *Nancy Drew* mystery novels under her covers. As late as the 1960s, another remembers hearing the clip-clop of horses' hooves as someone went riding at daybreak. Since 1939, the annual Halloween Parade down Broadway Avenue has also provided cherished memories for thousands of Beechview children.

The teenage years involved taking the streetcar every day to attend South Hills High School or traveling into town to attend Connelley Vo-Tech. Many teenagers remember working at Johns' Drug Store and even meeting their future spouse there.

One former resident who spent his formative years in Beechview was Apollo astronaut James B. Irwin (1930–1991). A graduate of the U.S. Naval Academy, Irwin attended Holy Trinity Lutheran Church as a boy. In 1971, as part of the Apollo 15 mission, he walked on the moon. Somehow, by growing up on the ridge, this future astronaut was inspired to reach for the stars.

Warm and cherished reminiscences of a Beechview childhood include school, church, family, and friends. These are the fundamental themes that together weave a rich tapestry of memories to share.

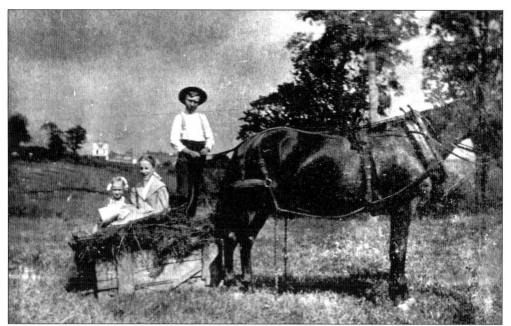

Pictured here are the youngest members of the Neeld family at the turn of the 20th century. They were born in Union Township, but grew up in Beechview and never moved away. Generations of Neeld children lived in Beechview and played in the fields surrounding the big house on Broadway Avenue. (Courtesy Donald P. Neeld.)

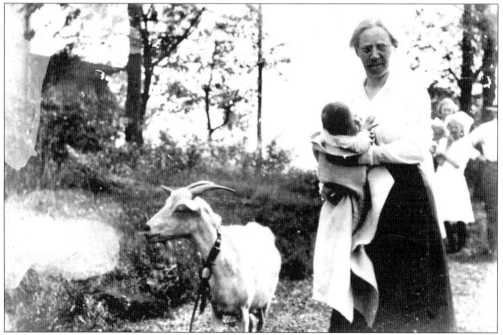

Elmer (1875–1940) and Ida Anderson Johnson (1874–1953), Swedish immigrants, married at her sister's home in McKeesport on August 29, 1902. The Johnsons moved to 2121 Vodeli Street around 1904 and reared seven children. Here, Ida holds the couple's last child, Margaret, who was born in 1918. The family kept a goat to provide fresh milk for the baby. (Courtesy Janet Felmeth.)

In the spring of 1922, Mary Mildred Burgess smiles sweetly from a wicker chair in the front yard of her family home at 1504 Methyl Street. Baby Mary, nine months old, died of whooping cough just a few weeks later, on June 6. (Courtesy Florence Burgess Coyne.)

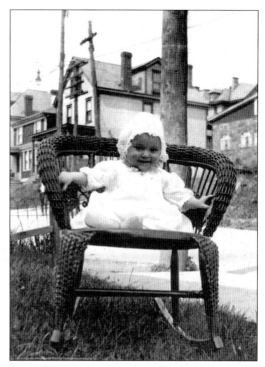

Generations of Beechview residents recall riding into Pittsburgh on the trolley to shop downtown. Here, Anna, Pierina, Louis, and Adam DeGasperi wait for the trolley at the Pennant streetcar stop in 1922. The family moved to Beechview in 1916 from the Hill District, and purchased a home at 226 Sebring Avenue. (Courtesy Virginia DeGasperi Noceti.)

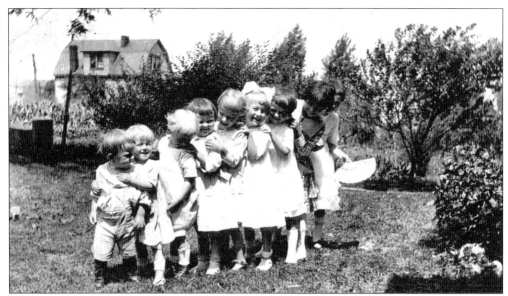

Children celebrate a birthday in the Winge family backyard on Fallowfield Avenue in the early 1920s. Pictured from left to right are Paul Egan, Doris Jean Winge, Eleanor Winge, Annie Egan, Ruth Nelson, Marion Winge, Kitty Egan, Catherine Mazzari, and Helen Egan. (Courtesy Marion Nelson Johnson.)

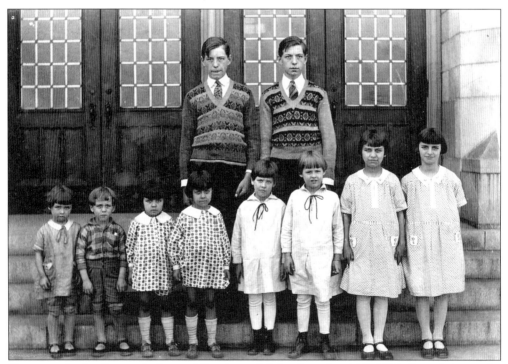

Five sets of twins line up in front of Beechwood School on April 18, 1928. From left to right are the following: (first row) Pauline and Paul McCall, Janet and Jeanne Hirsch, Edith and Edna Oyler, and Anne and Dorothy Braum; (second row) Frederick and Richard Marsh. (Courtesy Beechwood School.)

The "Dead End Gang" of Broadway Avenue in the mid-1920s included, from left to right, Eddie Cerminara, Al Cerminara, Bill Nelson, Jack Nelson, Marion Nelson, and hiding in the shadows, Ruth Nelson. (Courtesy Marion Nelson Johnson.)

Best pals Mary Wertz (left) and Florence Burgess stand on the wooden sidewalk bordering the 1300 block of Belasco Avenue in 1930. (Courtesy Florence Burgess Coyne.)

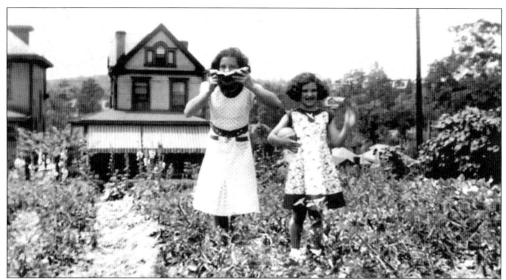

For sisters Joan (left) and Virginia Mascaro, summer memories from about 1935 include wearing crisp sun dresses and savoring sweet watermelon from their father's garden at 276 Sebring Avenue. (Courtesy Joan Mascaro Gaetano.)

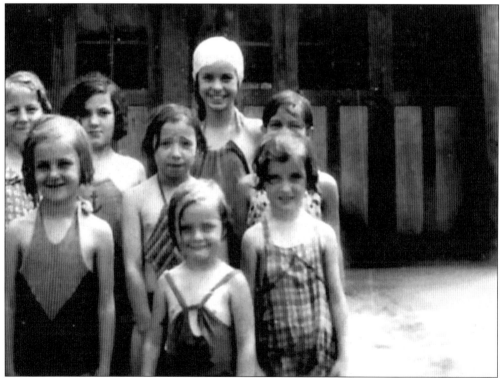

Childhood fun in the mid-1930s included running through the fire-hydrant spray on a hot summer day. Pictured on Sebring Avenue during a break in the action are, from left to right, the following: (first row) Beverly Green, Sue Green, and unidentified; (second row) Ramona Knorr, Virginia Mascaro, Betty Jean Lascher, Virginia DeGasperi, and unidentified. (Courtesy Joan Mascaro Gaetano.)

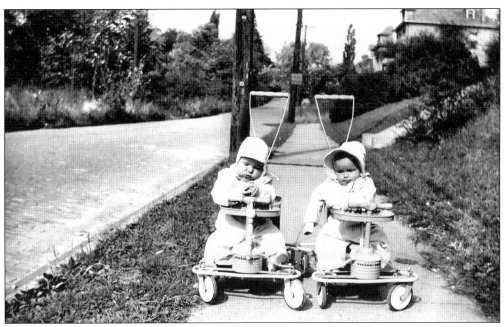

Born in January 1948, twins Bobby (left) and Bonnie Dietz sit in their matching strollers on Tropical Avenue. (Courtesy Wilda Triplett Dietz.)

The Halloween Parade, sponsored by the Beechview Community Council, is a special memory for thousands of Beechview residents. Here, in October 1952, costumed youngsters rest on the steps in front of Beechview Hardware on Beechview Avenue. From left to right are the following: (first row) Suzanne Burgess, Alice Burgess, and Eileen Coyne; (second row) Paulette Burgess, Mary Anne Coyne, John Coyne, and Tom Burgess. (Courtesy Judy Coyne Williams.)

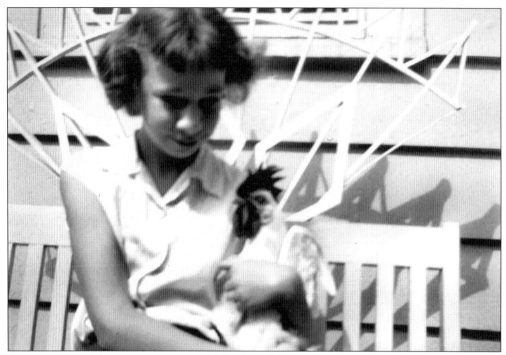

Anita Aiello holds her pet rooster at 1543 Methyl Street in 1953. The rooster was purchased as an Easter peep from the local five-and-dime and grew into the family pet. Greeting each day with a lusty cry, the rooster became an annoyance to the neighbors, and the authorities were notified. Sadly, to resolve the dilemma, Anita's grandfather prepared a pot of chicken soup. (Courtesy Cara Jones.)

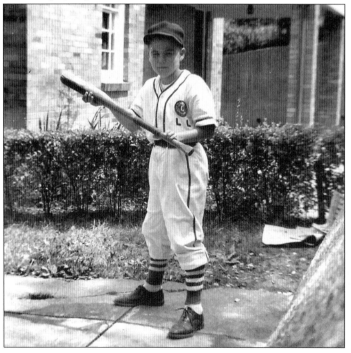

Paul Pfeuffer prepares to bunt on Shiras Avenue in 1954. Paul's Little League team, the Tigers, played first at Alton Field and then at Vanucci Field. (Courtesy Sue Pfeuffer.)

Resting from a game of badminton, Janet Rosfeld (left) and friend Vera Santoro lounge in front of 1503 Kenberma Avenue in 1965. Backyard badminton was a popular pastime in the 1950s and 1960s. (Courtesy Janet Rosfeld.)

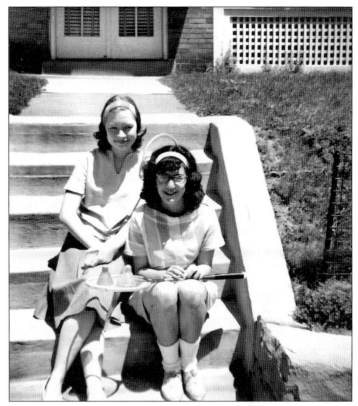

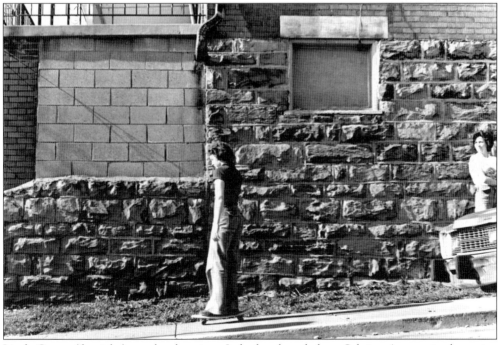

Linda Coyne (far right) watches her sister Judy skateboard along Sebring Avenue in the spring of 1976. (Courtesy Judy Coyne Williams.)

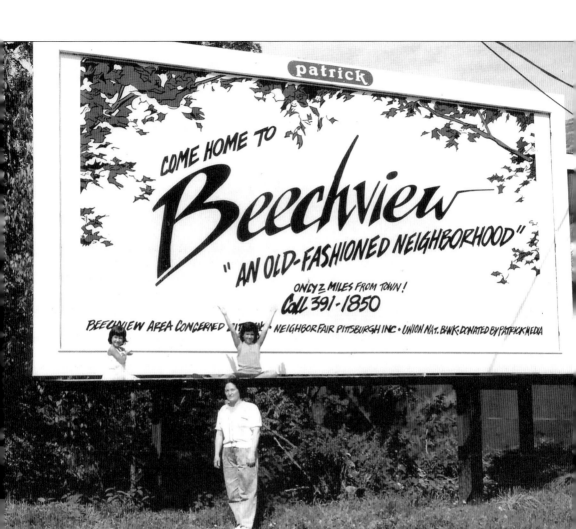

Renee (left) and Marisa DiDiano share their exuberance as they sit on a Broadway Avenue billboard in the late 1980s. Their grandmother Angela Pasquale stands beside them. This billboard, sponsored by the Beechview Area Concerned Citizens (BACC), promotes the virtues of residing in the town. An organization formed in 1987, the BACC has been a dynamic force for advancing projects beneficial to the community. (Courtesy Angela Cavaliere Pasquale.)

Four
ENTERPRISE

The earliest occupation in the area was farming. The 1851 *Map of Allegheny County Pennsylvania with the Names of Property Owners* indicates the names Snodgrass, Crane, Wilson, Algeo, Curran, and Foster. Two businesses are named on the map: a woolen mill near Carnahan and Banksville, and a tannery near Wenzell and West Liberty. The top of the ridge (now Broadway Avenue) separated Chartiers Township in the west from Lower St. Clair Township in the east.

Coal mines and lime kilns occupied this area as early as 1825. The coal-mining industry expanded greatly from 1830 through 1920, supplying essential coal and jobs for area residents. Initially, many of the coal mines were family owned and operated.

The Pittsburgh Coal Bed forms the rich veins of bituminous coal that underlie the hills of Beechview and indeed most of southwestern Pennsylvania. In fact, this coal bed is the most important in the state and is considered to be of excellent quality. An 1884 map of the bituminous coal district near Pittsburgh indicates numerous mines in the area. The Coal Ridge mine seems to lie directly under Beechview, with the larger Venture mine on the opposite hill in Banksville. Both mines were owned by Gray & Bell and, in 1884, employed more than 200 men, and together produced 12,000 bushels of lump coal per day.

The 1886 *Atlas of the Vicinity of the Cities Pittsburgh and Allegheny, Penna.* indicates the names of Bandi, Bulford, Lonergan, Lowen, Mulholland, Neeld, and Price. Dairies, orchards, and truck farms sustained these families. Union Township lay to the west of the ridge, and West Liberty Borough to the east.

The turn of the 20th century saw the development of much of the farmland into streets and house lots and the expansion of the trolley lines south of the city. The original general store made way for grocery and hardware stores, pharmacies, tailor shops, beauty salons, and funeral homes. This economic development is indicated by *Polk's Pittsburgh City Directory 1908*, which mentions established businesses in Beechview for the first time, even though Beechview was not yet a part of the city. The Beechview Inn, at Broadway and Lowen (now Coast); the Beechview Pharmacy, at Pennsylvania and Seventh Avenues (Hampshire and Beechview); and the Beechview and Mt. Lebanon Transfer Company, at 691 Broadway Avenue, are all listed.

In 1924, the opening of the Liberty Tunnels encouraged further commercial development of the South Hills. After World War II, the popularity of the automobile and the development of shopping centers and indoor malls increasingly attracted consumers. The competition gradually forced many small, family-owned businesses to close. Today, community activists, working with the city and innovative entrepreneurs, plan to redevelop the business district and establish a new economic vitality there.

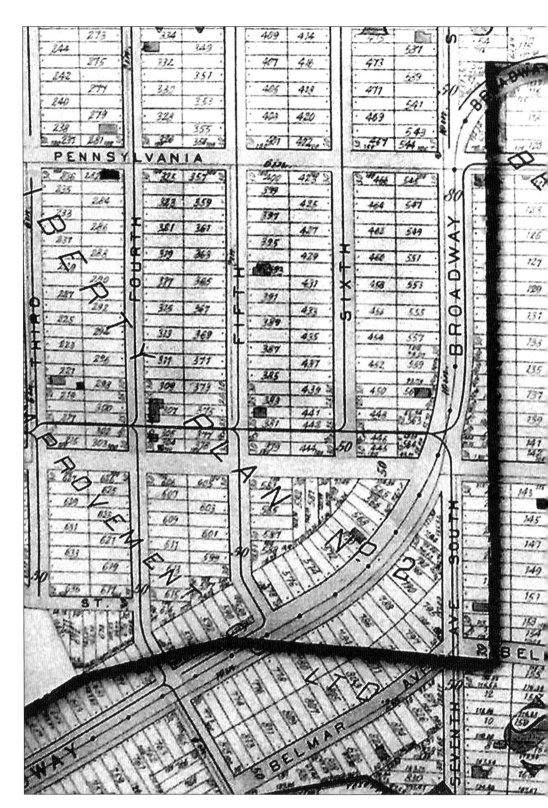

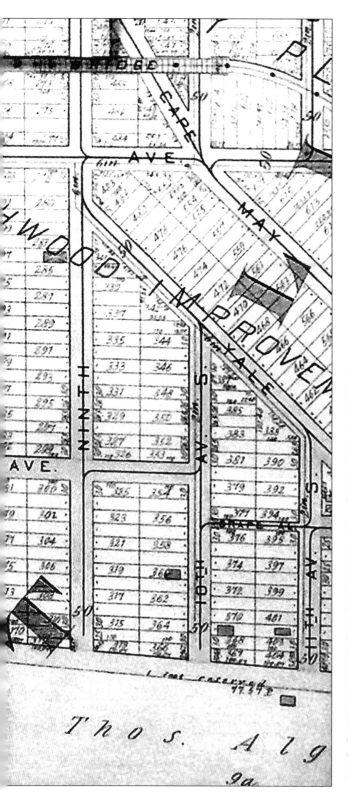

Between 1902 and 1904, the Beechwood Improvement Company laid out five lot plans that spanned both Union Township and West Liberty Borough. The 1903 plan indicated that a strip of land 30 feet wide was to be reserved in the center of Broadway Avenue. Along this span, the trolley tracks were installed in 1904. This plate from the 1905 *Real Estate Plat-book of the Southern Vicinity of Pittsburgh, Penna.* reveals only modest construction in Beechview, although the lots have been laid out, the streets have been named, and the single-track trolley line along Broadway Avenue has been established. New businesses progressively developed along Beechview, Broadway, and West Liberty Avenues. By 1929, the *Polk Directory of Pittsburgh* registered numerous small businesses nestled among family dwellings on these three main corridors of commerce. (Courtesy Historical Society of Western Pennsylvania.)

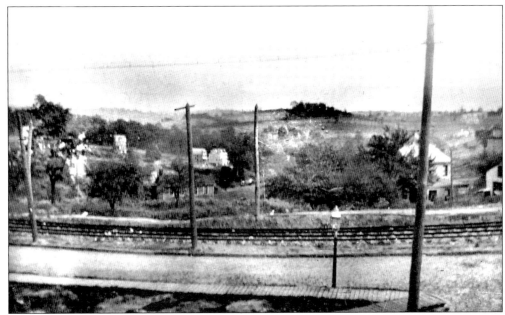

In the foreground of this *c.* 1907 view, Beechview Avenue joins Broadway just before the track crosses the bridge at Fallowfield Avenue on the left. No commercial development exists along this stretch of road, and the sparsely settled hillsides are visible to the southeast. This early image reveals the first wooden sidewalks used by pedestrians to negotiate the unpaved streets. A gas streetlight is evident in the foreground. (Courtesy Barbara Haggerty.)

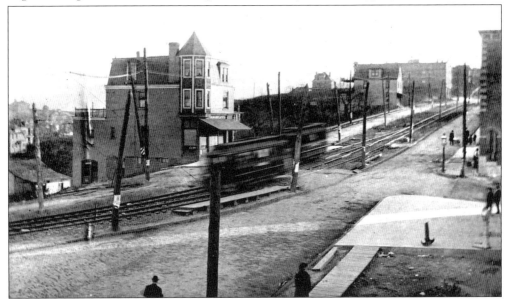

Moving west from the previous scene, this view shows the business hub of Broadway, Beechview, and Hampshire. Note how the trolley line expands at Hampshire from one to two tracks on the approach to the bridge. The Pittsburgh Railway Company operated Streetcar Line 42 to Beechview on a single track along Broadway until 1913, when heavy traffic necessitated the installation of a second track from Hampshire to Neeld Avenue. (Courtesy Barbara Haggerty.)

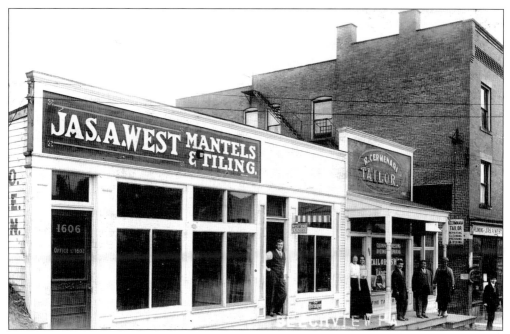

This *c.* 1913 postcard shows the west side of Broadway Avenue. James A. West's mantel and tiling business provided goods and services for the many property owners building homes in the area. Ralph Cerminara owned the tailor shop seen on the right for several years. Both West and Cerminara lived on Rutherford. (Courtesy of Paul Dudjak.)

A sizeable Jewish community thrived in Beechview. Many families began arriving in the area before World War I. This advertisement appeared in *The Pittsburgh Jewish Community Book* of 1921. The interior-decorating firm of Edward W. Learzof, located at 1600 Broadway Avenue, also served the needs of new homeowners in the neighborhood. (Courtesy Carnegie Library of Pittsburgh.)

Edw. W. Learzof

Interior Decorators

In All Branches

Churches, :-: Scenery,
Wall Paper, Painting.

Sketches Submitted

1600 Broadway. Phone Locust, 1260

Phone, Lehigh 7847-J

Pittsburgh, Pa.————————19——

M————————————————————————

W. K. BULFORD

EXCAVATING, HAULING, COAL and MOVING
ESTIMATES FURNISHED

Crane Avenue

Beechview

Prompt and Courteous Service Guaranteed

On the north end of the ridge, farming persisted, although farmers often had to supplement their incomes. This business letterhead indicates that Walter Kennedy Bulford (1905–1966) developed other enterprises during the Depression years in order to support his family. Walter's neighbor Harry Shaffer also worked as an excavator. (Courtesy Daniel Bulford.)

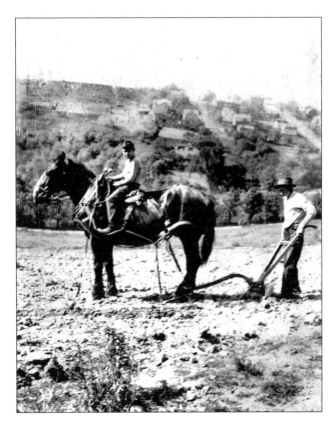

Pictured here in 1935 astride the family horse is 11-year-old Harry C. "Petie" Shaffer, son of Harry and Josephine. Behind the plow is John K. "Hutchie" Hodgson, known as "the Johnny Appleseed of Beechview," who nurtured orchards on the former Lowen property. John owned several acres adjacent to Crane Avenue but lost his property through a bank foreclosure during the Depression. In the background, Dagmar and Fallowfield Avenues roll over the hill to the south. (Courtesy Joseph Shaffer.)

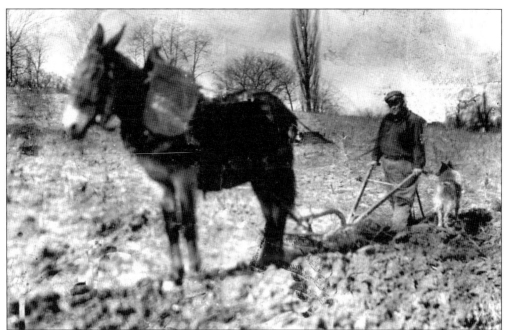

Harry Shaffer (1903–1965) and his wife, Josephine Wamboldt Shaffer (1905–1989), married in 1923 and purchased the Lowen Farm in 1940. Here, in the 1940s, Harry plows with his mule Jennie, accompanied by the family collie, Shep. In good years, several hundred bushels of pears and hundreds of dozens of eggs were yielded by the farm. Josephine churned cream to make butter and sold it to customers in Beechview. The last cows on the property were sold in 1964. (Courtesy Joseph Shaffer.)

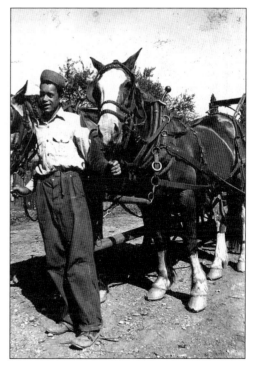

Andrew Jones worked on the Shaffer Farm during the 1940s. He walked to work from his home on Mt. Washington. Jones reportedly loved horses and looks at ease with this team. Beechview residents of the era remember hearing the hooves and cartwheels on neighborhood streets, and seeing the produce for sale from the back of the wagon. (Courtesy Joseph Shaffer.)

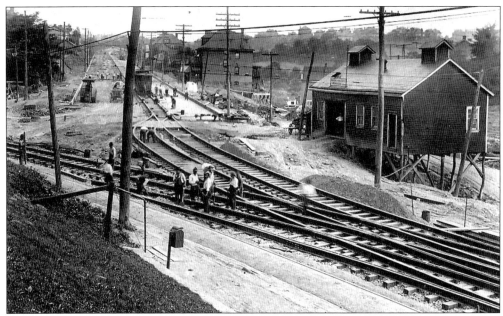

In this *c.* 1915 southward view, the expansion of the West Liberty Avenue trolley line is evident. A branch continues up Brookline Boulevard to the left. The trolley and the tunnels brought increasing development along West Liberty Avenue, including the expansion of numerous new- and used-car establishments. The Kerr blacksmith shop stands precariously along the corner of West Liberty and Wenzell Avenues. (Courtesy Carnegie Library of Pittsburgh.)

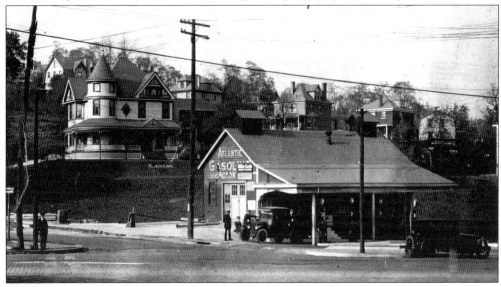

This is the same corner depicted in the previous image, but photographed from a different angle some years later. As the automobile grew in popularity so did the proliferation of repair shops and gas stations. Here now stands the Kerr gas station. Owned by George M. Kerr, this building originally served as his blacksmith shop until it was replaced by the gas station in 1919. Behind the station is the Kerr Homestead, built about 1898. The house and the station were torn down around 1950 and replaced by an A&P grocery store. Located at this site today are a McDonald's Restaurant and a Jiffy Lube. (Courtesy George H. Kerr.)

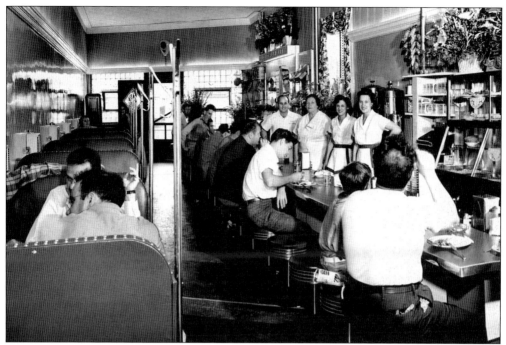

Remembered by many as a popular gathering place, Babe's Restaurant was established at this second location on Broadway Avenue. Owner Babe Folino stands in the center, facing the camera, in July 1947. His first establishment, known as Babe's Diner, stood across the street on land now occupied by the Foodland parking lot. (Courtesy Pearl Ehrenberger.)

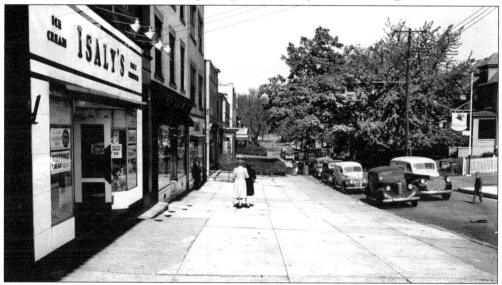

Isaly's Dairy was popular for decades. At its peak, Isaly's included 11 plants and more than 400 dairy stores in western Pennsylvania and Ohio. Many happily remember consuming Skyscraper ice-cream cones and Klondikes, a special Isaly's invention. An Isaly's store at 1544 Beechview Avenue served residents from 1935 to 1947. This 1945 view looks north on Beechview Avenue. Another dairy store, Bard's Dairyland, operated at 1554 Beechview Avenue from about 1934 to 1962. (Courtesy Pittsburgh City Photographer Collection, University of Pittsburgh.)

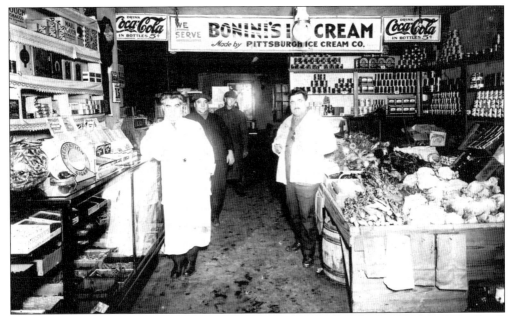

Before the arrival of national grocery stores such as A&P, Kroger, Thorofare, and Foodland, small family-owned stores dominated the grocery trade in Beechview. This 1920s interior view of the Beechview Produce Company shows Tom Arrigo (front left) and brother Lawrence Arrigo (right) at 1542 Beechview Avenue. Lawrence later owned a store at Broadway and Crosby Avenues. (Courtesy Jackie Ciccone Heidenrich.)

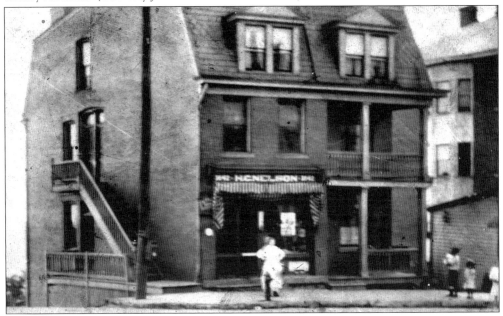

Swedish immigrants Carl G. Nelson (1890–1927) and Hulda Caroline Nordstrum Nelson (1889–1961) purchased a building at the corner of Coast and Broadway in 1916. The Beechview Inn had previously occupied this building, when the property was owned by a Mrs. Cook. The Nelsons opened a grocery store here. After Carl died, Hulda operated the business herself. This image shows her name on the front of the store. (Courtesy Marion Nelson Johnson.)

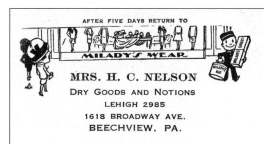

Olaf "Olie" Olsen (grocer) and Joseph Berthold (butcher) later acquired the Nelsons' business, but Hulda continued to own the building. Olsen's Market served the community for decades. An enterprising businesswoman, Hulda later opened a dry goods and notions shop at 1618 Broadway. This envelope displays her shop's letterhead. (Courtesy Marion Nelson Johnson.)

The Alma Pearl Beauty Service provided women with permanent waves, according to this 1934 advertisement. Even during the economic restrictions of the Depression, women found the money to get their hair cut, styled, and dyed. (Courtesy Sue Pfeuffer.)

This 1930s advertisement promotes the Delise Beauty Shoppe. Other beauty salons operated in Beechview, as well. Nelson's Beauty Shoppe, at 1662 Broadway, was owned by Ruth Nelson, daughter of local entrepreneur Hulda Nelson. The Carmell Beauty Salon greeted customers at 1612 Broadway. And in the late 1940s and early 1950s, an enterprising African American woman, Cora B. Williams, operated a beauty shop and a doll hospital at 1609 Broadway. (Courtesy Sue Pfeuffer.)

Possibly the first funeral home in Beechview, William Slater and Sons originally stood at 1940 Broadway Avenue. The firm later moved to the corner of Shiras and Bensonia, where the Brusco-Napier Funeral Home now serves the community. Raymond S. Phillips opened the Phillips Funeral Home (later Phillips and Krainak) at 1923 Broadway Avenue around 1952. William Eckels purchased the business in 1973. (Courtesy Sue Pfeuffer.)

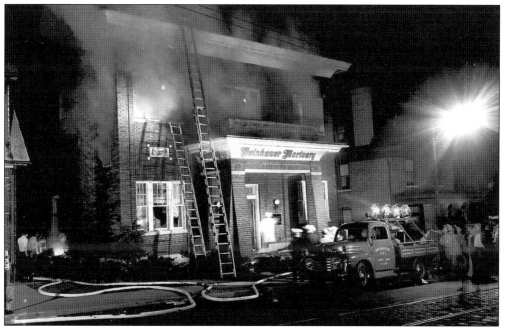

Louis Beinhauer opened his first mortuary in 1860 on Third Avenue. The Beinhauers opened two other branches on the South Side. In 1910 the family moved its business to West Liberty Avenue, incorporating all facilities there in 1921, including Pittsburgh's first crematory. In 1952, a seven-alarm fire (pictured) utterly destroyed the building. The business was rebuilt and continues to serve Beechview and the South Hills community. (Courtesy AIS Pic File, University of Pittsburgh.)

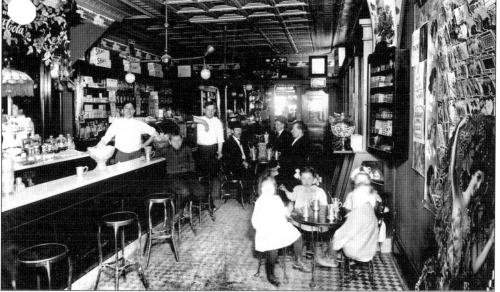

Johns' Drug Store, a popular establishment, lives on favorably in the memories of Beechview residents. John A. Johns opened his pharmacy in 1907 at 1550 Beechview Avenue. In the early years, it was called the Beechview Pharmacy. This photograph reveals the inside of the original store, including the soda fountain. Johns poses on the left, behind the counter. (Courtesy Barbara Haggerty.)

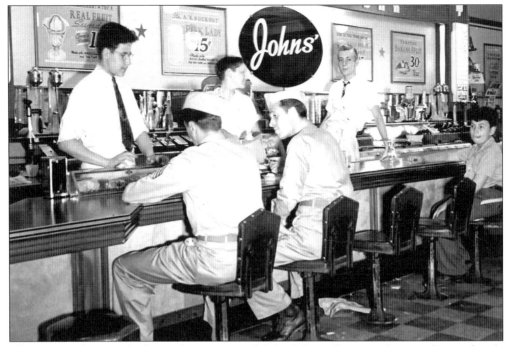

This 1940s photograph shows the interior of Johns' Drug Store, with its redesigned soda fountain. The soda bar was a special feature of the pharmacy. Behind the counter are, from left to right, Rich D'Uva, an unidentified employee, and Dick Leitholf. Another amenity of the store was the substation of the post office, which served customers for decades. (Courtesy George Keiser.)

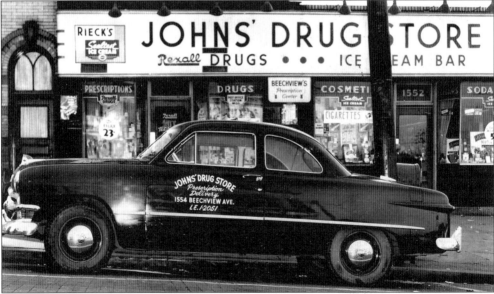

John A. Johns retired in 1941. His nephews Elmer William Haggerty and George Johns Haggerty acquired the pharmacy and continued to operate the business successfully for several decades, expanding into the adjacent space. This 1950s image shows the expanded store and the Ford delivery vehicle. (Courtesy Barbara Haggerty.)

Over the years, Johns' Drug Store sold everything from television tubes to toys, candy, and cosmetics. This advertisement was printed in the *Beechview News* on June 30, 1950. The Haggerty family sold the pharmacy in 1980. Competition from large chain drugstores and the advent of health maintenance organizations contributed to the decline of many small independent pharmacies, including Johns' Drug Store, which closed its doors in November 2000. (Courtesy Chelsea Hammond.)

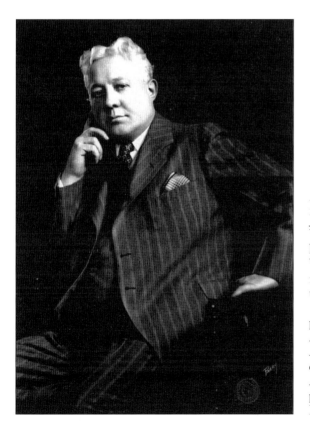

Born in Swansea, Wales, in 1881, John Arthur Johns immigrated to the United States with his family when he was five years old. He attended the University of Pittsburgh, graduating in 1905. The Indian Head penny at the bottom of this portrait is dated 1907, the year Johns opened his pharmacy. He was a director of the Allegheny Retail Pharmacists' Association and was active in local civic affairs. Johns died in Mercer on April 5, 1942. For 93 years, his pharmacy anchored the economy of Beechview. (Courtesy Nate Marini.)

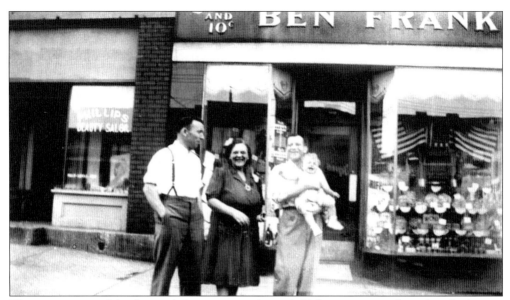

The prominence of the five-and-dime store in the mid–20th century is reflected in the history of Beechview's main street. The Ben Franklin five-and-ten, located at 1610 Broadway Avenue in the early 1940s, became the Beechview five-and-ten, and finally Morry's five-and-ten. Pictured here are Nathan Stalinsky, Pauline and Sam Salkovitz, and young Gladys Stalinsky in 1943. Sam Salkovitz purchased the Ben Franklin store and successively owned all three of the popular five-and-dimes. (Courtesy Gladys Stalinsky Maharam.)

Several successful family-owned businesses were established in the Broadway block between Boustead and Crosby, among them Kay's Market and Arrigo's Market. Now upscale dining spots such as Davio's Restaurant share sidewalk space with Nelle's Diner and a succession of pizza shops. This is a current trend in city neighborhoods. (Courtesy Anna Loney.)

Five

A TRADITION
OF SERVING OTHERS

Attending to the needs of others is the hallmark of any great community. In Beechview, examples can be seen in the many altruistic efforts of its people. Support exists for all citizens of Beechview, be they children, adults, or the elderly.

A plaque recently placed in the basement entrance to the former Beechview Christian Church (now Mercy Behavioral Health) on Broadway and Shiras Avenues provides eloquent testimony to this tradition of service:

> In honor and recognition of the board members of the Southwest Pittsburgh Community Mental Health and Mental Retardation program, Pioneers who through resolute efforts and staunch personal commitment labored creatively to develop the first comprehensive community services for people with mental illness and mental retardation in the southwest part of the city of Pittsburgh in 1969. Today, thirty five years after the genesis of an idea, their legacy lives on in the many lives which continue to be aided by the efforts of the human service employees of Mercy Behavioral Health who have carried the gauntlet since 1987 at the same location.

Beechview residents have a history of recognizing acute needs in their community and systematically responding, for the benefit of their fellow citizens and the community at large. The Southwest Pittsburgh Mental Health and Mental Retardation Program, the German Orphan Asylum, the National Guard, the Carnegie Library of Pittsburgh, the Grandview Cemetery, and Engine Company No. 60 have all provided the Beechview community, the South Hills, and the nation with vital services.

Members of the Beechview Community Council, the Beechview Lions Club, and the Beechview Area Concerned Citizens all have a tradition of identifying local needs and addressing them with energy and tenacity.

Concerned residents have found ample and worthy causes to pursue in Beechview over these hundred years. Safety is but one cause, which from the beginning has been paramount. When, in 1912, the growing population density necessitated modern fire services for protection, Beechview challenged the city of Pittsburgh to address this need. Because of the unique topography of Beechview, including steep, populated hills, conventional fire-safety methods would not work. And the horse-and-wagon fire protection of the 19th century could not meet the needs of this 20th-century community. Thus, Beechview became the first community to incorporate an internal-combustion motorized fire truck in the city of Pittsburgh. Recognizing a community need, Beechview's Engine Company No. 60 led the way toward efficiency and modernization.

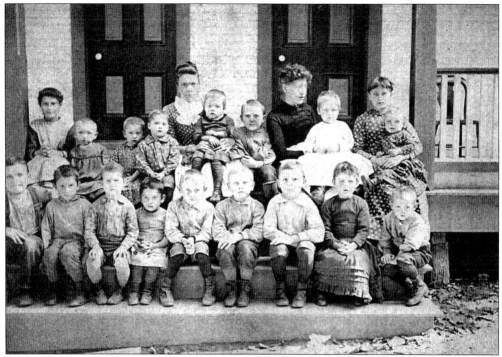

This 1888 photograph documents the beginning of an institution that would become Fair Oaks of Pittsburgh. Rev. Frederick Ruoff established the German Protestant Orphan Asylum of Pittsburgh in 1887 on the site of the West Liberty home of the Demmler family. The house was remodeled and enlarged for the first children who were admitted in 1888. Marianna Werneberg served as the matron until her death in 1917. (Courtesy Fair Oaks of Pittsburgh.)

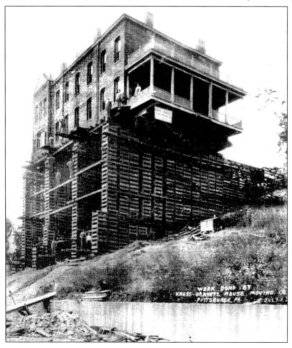

This photograph shows the effort that was undertaken to relocate the original orphanage that stood near the corner of West Liberty and Pauline Avenues. Notice the men strategically positioned throughout the structure at the time of the move. In 1924, the Kress-Oravetz House Moving Company pushed the structure up the hillside to its new location. This photograph illustrates the complexity of the task. The underpinnings were used to first raise the structure and then maneuver it to the new resting place. (Courtesy Nate Marini.)

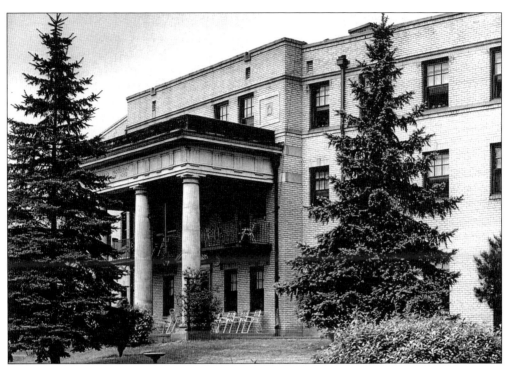

In 1926, an addition was made to the orphanage, and work began on a new home for the aged. Called Altenheim, this home for the elderly was constructed on the hill next to the orphanage. Together, the two institutions were known as the Congregational Homes. The orphanage closed in 1941, and the Salvation Army moved its Booth Memorial Hospital into the building in 1945. Established in 1900, the institution provided a home for unwed expectant mothers. A new north wing was added in 1965. (Courtesy Fair Oaks of Pittsburgh.)

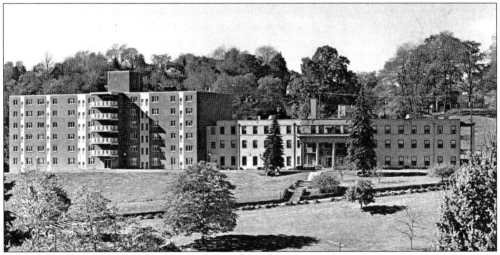

Plans to renovate and expand the Altenheim began in 1972, culminating with the 1978 addition of a lovely, six-story high-rise building. The Congregational Homes bought back the former orphanage building from the Salvation Army in 1991. That structure was eventually razed and the grounds were relandscaped for the enjoyment of the residents of the newly named Fair Oaks of Pittsburgh Retirement Community. (Courtesy Paul Dudjak.)

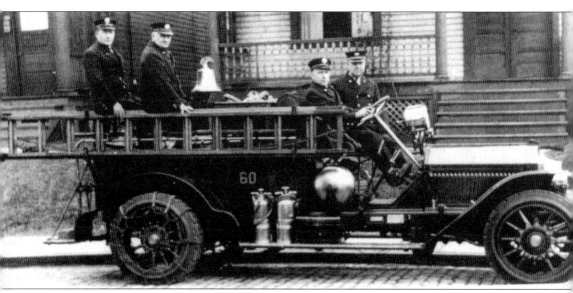

Beechview authorities pressured the city of Pittsburgh to address the growing need for a motorized fire truck. Because of the height and slope of many streets (three streets in Beechview rank among the top ten in Pittsburgh for the most acute slope), vehicles were needed to move the firefighting equipment up and down the hills quickly. This mighty American LaFrance pumper carried a 35-gallon chemical tank. In 1912, this apparatus represented the most modern firefighting equipment in all of the city of Pittsburgh. Soon, Pittsburgh began to upgrade to motorized equipment, but Beechview will always be remembered as the first community to do so. (Courtesy Reid Scharding.)

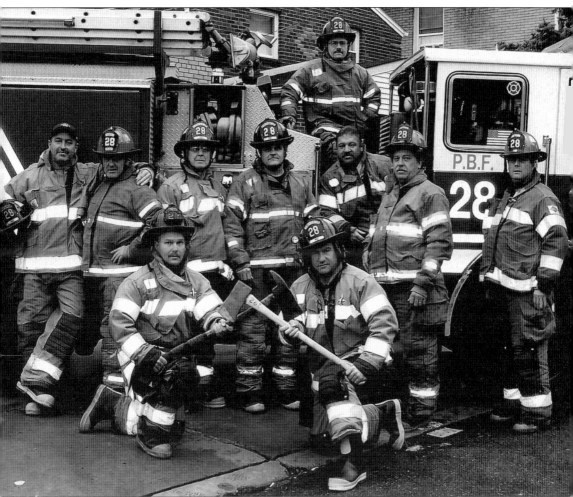

There are 4 captains and 16 firefighters in Engine Company No. 28. This company is an outgrowth of the original Engine Company No. 60, organized on February 1, 1912. Its current location, at the intersection of Beechview and Sebring Avenues, previously housed the Beechview Presbyterian Church. In 1942, the city of Pittsburgh purchased the former church, tore off the roof, and extended the walls upward to accommodate the modern engine room and quarters. Company members seen in this November 12, 2004 photograph are, from left to right, as follows: (first row) Thomas Wosko and Timothy Kernan; (second row) Victor Muto, Capt. Dale Aubrecht, Stanley Walter, Raymond Ducouer, Pasquale Chirumbolo (standing on pumper), Ronald Truver, Capt. Reid Scharding, and Capt. Robert Cromie. (Courtesy Reid Scharding.)

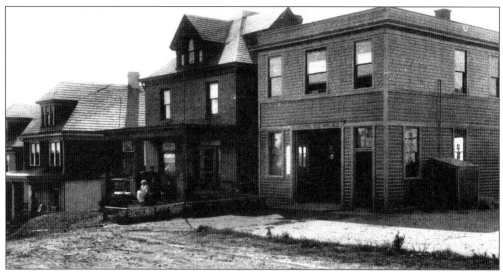

The first home of the old Engine Company No. 60 was at 1410 Fallowfield Avenue. The house still stands today. An expanded view of Fallowfield, south of the firehouse, may be seen on page 16. (Courtesy Reid Scharding.)

Beechview celebrates the dedication of its new Community Oriented Police Station (COPS) on May 5, 1994. John White was the first COPS officer assigned to the Beechview station located in the basement of the Beechview United Presbyterian Church. Pictured here are, from left to right, BACC president Judy Dyda, an unidentified officer, officer John White, Pittsburgh mayor Tom Murphy, state representative Frank Gigliotti, councilmen Joe Cusick and Dan Cohen, and an unidentified woman. The COPS concept was abandoned by the city in 2003. (Courtesy Beechview Area Concerned Citizens.)

The Congregational churches established the First German Evangelical Protestant Cemetery on property originally adjacent to the orphanage in West Liberty. The cemetery provided a resting place for Congregational church members who were not Beechview residents. The cemetery became known as the Grandview Cemetery when it was purchased in 1970 by the Grandview Church of God, which had relocated to property adjacent to the cemetery. Currently, there are 2,000 grave sites here, 17 of which are soldiers' graves. (Courtesy Anna Loney.)

Standing on the site of the former synagogue, the new branch of the Carnegie Library of Pittsburgh opened to the public in June 1967 and was dedicated on October 19, 1967. A bookmobile had previously been available to Beechview residents, but the addition of 5,600 square feet of space and a capacity for 30,000 books attracted young and old. (Courtesy Carnegie Library of Pittsburgh.)

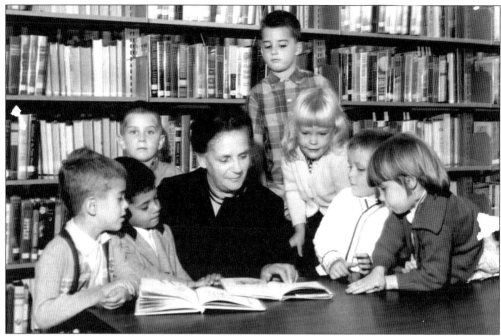

Four individuals were honored for their efforts in the planning of the library: Mrs. Eugene Shopf, who did not live to see the project's completion; Dr. Thomas Burkhardt, principal of the Beechwood Elementary School; Al Wills, Scout master of Troop No. 229; and Mrs. William J. Plunkett, former president of the Beechview Community Council. Here, city council representative Irma M. D'Ascenzo shares books with the new library's youngest patrons. (Courtesy Carnegie Library of Pittsburgh.)

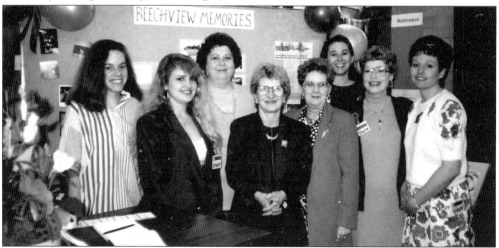

Through the years, library managers Ruth Collura, Janet Prescop, Ruth Rhen, Sandra Thompson, Wendell Cook, Linda Drago, Charmaine Spaniel Mozlack, Thomas Holmes, Joan Trautman, Marian Streiff, Sharon Verminski, and Audrey Iacone have guided the library to meet the needs of the community. In this photograph, staff members celebrate the library's 25th anniversary in June 1992. From left to right are Erin Gallaher, Ramona Folino, Sue Pfeuffer, Nancy Barker, Joan Trautman, Carolyn Wagner, Janet Rosfeld, and Eileen Devlin. (Courtesy Carnegie Library of Pittsburgh.)

The Beechview Area Concerned Citizens (BACC) formed in 1987. One of its first projects was the adoption and maintenance of Monument Parklet. Over the years, this group has sponsored the FoodShare Program, Beechview Bundle Up, KidsFest, Night Out Against Crime, block parties, and more. Shown here with the newly dedicated Korean and Vietnam War Memorial in 2000 are, from left to right, Phyllis DiDiano, Doris Priore, Joan Gaetano, Annie Lendl, and Sue Pfeuffer. (Courtesy Beechview Area Concerned Citizens.)

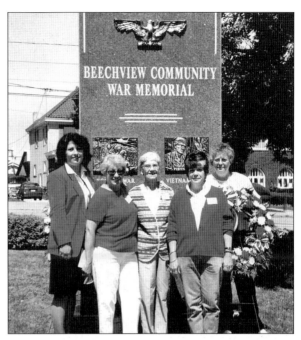

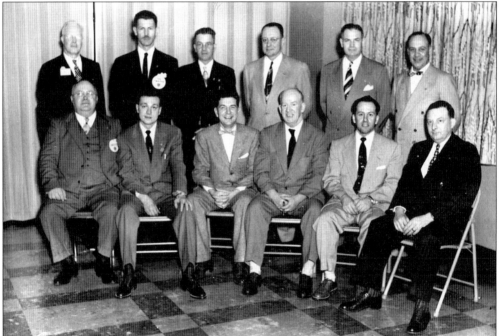

Receiving its charter in 1953, the Beechview Lions Club began with 42 members. The Lions created the Beechview Little League and the Meals-on-Wheels program. The group also donates money annually to the Pittsburgh Guild for the Blind. Pictured here are some of the club's members from the 1950s and 1960s. From left to right are the following: (first row) John Rebol, Bill Smith, George Haggerty, John Cloherty, Jack Kalvelape, and Jerry McKay; (second row) Joe Parker, Dale Campbell, Tom Burr, Dr. ? Day, Bud Phillips, and Pete Caruso. (Courtesy Richard DaBecco.)

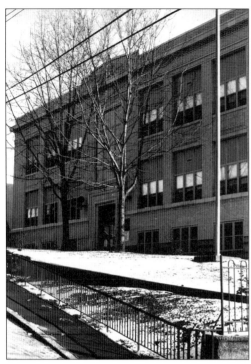

A premier senior housing option, Gualtieri Manor was opened in the former Lee School, at Los Angeles and Shiras Avenues, in 1985 after extensive building and modification. Operated by the Pittsburgh Housing Authority, the facility was named for Frederick Gualtieri of Beechview. A noted labor leader and charity fund-raiser, Gualtieri served on numerous boards, including the housing authority. He died on November 21, 1983, at age 57. (Courtesy Anna Loney.)

In the spring of 1987, ground was broken for the construction of another senior citizen high-rise known as Beechview Manor, a 52-unit building comprised of 40 one-bedroom apartments and 12 efficiencies. Located near St. Catherine's Church, the Manor was opened for occupancy on September 13, 1987. This thoroughly modern facility has a constant waiting list because of its many amenities. (Courtesy Beechview Manor.)

The 128th Forward Support Battalion, Companies B and C, located on Crane Avenue, constitute an important arm of the Pennsylvania National Guard. Company B is the maintenance support of the battalion for the 2nd Brigade. Employing more than 250 soldiers, Company B fixes everything from trucks to high-speed laser rangefinders. Company C is the medical support, providing advanced trauma life support for injured soldiers and employing more than 70 soldiers, including physician's assistants, surgeons, and dentists. (Courtesy Anna Loney.)

On June 30, 2004, sixty-five Pittsburgh-area guardsmen left for deployment to Iraq. They became part of Task Force Dragoon, a mechanized infantry battalion formed by the 128th Forward Support Battalion and six other Pennsylvania National Guard units. This deployment marks the 128th's first deployment since the Korean War and its largest deployment since World War II. The 128th Pennsylvania National Guard descends from the historic Duquesne Grays, originally formed in 1831. (Courtesy Anna Loney.)

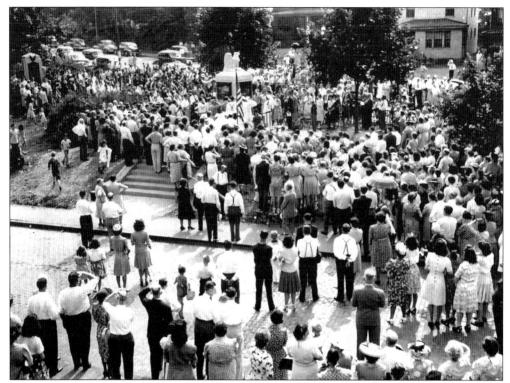

Even before the end of World War II, the citizens of Beechview and the members of the Beechview Board of Trade had planned and completed the preparations for the unveiling of the war memorial in Monument Parklet, located on the corner of Shiras and Broadway Avenues. The World War I monument, dedicated on October 24, 1920, was moved to the park prior to this dedication; it had originally stood at the corner of Hampshire and Beechview Avenues. (Courtesy Nate Marini.)

The camera captures the exuberance on the face of navy veteran Joe Gimigliano (center foreground) at the dedication of the World War II memorial. This remarkable gathering in the late 1940s created a lasting legacy that has endured with the consecration of the Korean and Vietnam memorial now located in the same park. Beechview's sons and daughters continue to answer the call to arms, as many are engaged in the conflict in Iraq. (Courtesy Nate Marini.)

A monument honoring those citizens who served in the Korean and Vietnam Wars was erected in 2000, and the dedication was held on Saturday, July 8, 2000. Here, state senator Jack Wagner addresses the attendees. A graduate of Indiana University of Pennsylvania, Wagner is a lifetime resident of Beechview and was recently elected auditor general of the Commonwealth of Pennsylvania. (Courtesy Beechview Area Concerned Citizens.)

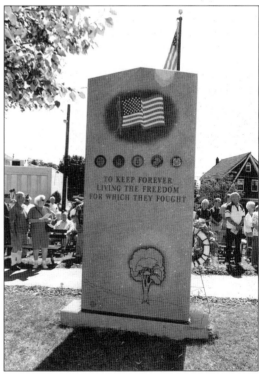

This photograph provides a full view of the newly dedicated Korean and Vietnam War memorial. The Beechview Area Concerned Citizens and state representative Frank Gigliotti were responsible for its conception and realization. (Courtesy Beechview Area Concerned Citizens.)

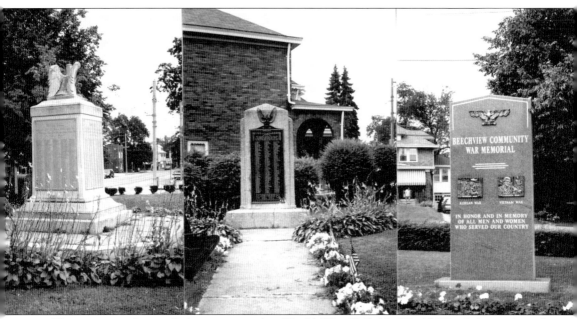

This montage shows all three memorials—World War II (left), World War I (center), and Korean and Vietnam—dedicated to those Beechview residents who answered their country's call to serve. (Courtesy Nate Marini.)

Six

SCHOOL DAYS

In the 19th century, most children living in rural areas were educated at home. Boys were trained in their father's trade, and girls learned the domestic arts. Although school buildings were rare, especially in southern Allegheny County, Beechview was served by the two-room West Liberty School, located across from Cape May Avenue.

In the 20th century, as the population increased, countless communities felt the need for better and closer schools. Between 1902 and 1904, with the influx of residents to the newly established Beechwood Improvement Plans, the two-room West Liberty School simply proved insufficient.

One of the first acts of the new Beechview Borough Council was to build a schoolhouse. In 1905, children were attending classes in the basement of the new Methodist church building at Pennsylvania and Sixth Street (Hampshire and Methyl). The Beechview School, known as "the red school," opened on January 1, 1906, on Sebring Avenue between Dagmar and Fallowfield. The first principal was Sarah Evans.

In 1908, West Liberty Borough erected a white-brick structure nearby and named it Beechwood Elementary School. It was identical in design to the Brookline School, built at the corner of Woodbourne and Pioneer Avenues. The Beechwood and Beechview Schools were combined in 1909, when both Beechview and West Liberty merged with the city of Pittsburgh. Beechview School was used as a prevocational school for boys until it closed in 1932. The building was razed in 1943, and the property was sold 10 years later.

Lee Elementary School honors Samuel R. Lee, who served as the secretary of the local school board for 25 years. The original frame building was erected in 1910 in what had been part of West Liberty Borough. A brick building was constructed in 1911 at Los Angeles and Shiras Avenues, adjacent to the frame structure. The first school was temporarily abandoned but became a kindergarten in 1913. Known as the Lee Annex, it closed in 1938.

St. Catherine's School opened in February 1915. Two Sisters of St. Joseph from Mt. Gallitzin arrived to teach the Roman Catholic students. Sister DeLourde, Mother Genevieve, and two lay teachers—Ann Fitzsimmons and Margaret Dunlap—organized classes and began instruction. In 1918, a second story was added.

Starting in 1917, high school students traveled to South Hills High School in Mt. Washington. Students interested in the trades attended Connelley Vocational in the Hill District. Other students opted to complete their education at one of the area parochial high schools. Beechview finally realized its own high school when Brashear High School was erected on Crane Avenue in 1976. South Hills Middle School opened in 1996.

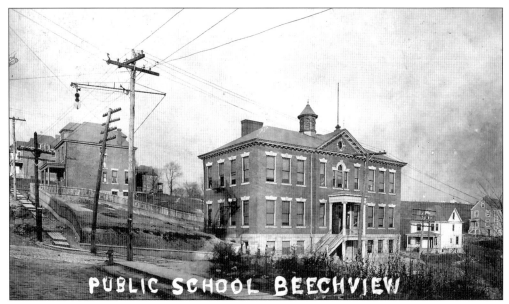

Constructed on the north side of Sebring, between Fallowfield and Dagmar, the Beechview School opened on January 1, 1906. Sarah Evans served as principal for the first term. H. G. Masters succeeded her in September 1906, and remained until 1922. This early postcard reveals "the red school" and its surroundings. (Courtesy Paul Dudjak.)

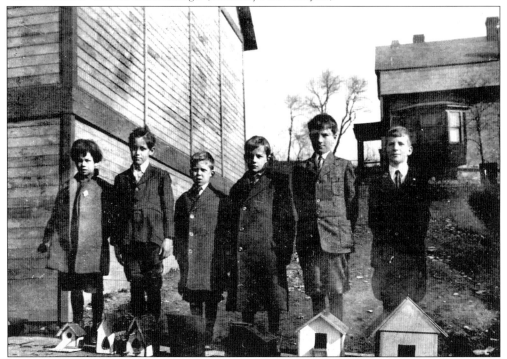

In 1906, Beechview students pose with their handmade birdhouses beside a wooden service building erected behind the red school. Beginning around 1924, Beechview served as a prevocational school for boys. The building was razed in 1943; however, one can still see the school's original retaining wall along Sebring Avenue. (Courtesy Beechwood School.)

This bell once hung in the Beechview School and called the students to class. It now resides on the front lawn of the Three Rivers Grace Community Church, the former Methodist church where, in 1905, Beechview children first gathered for classes in the basement. (Courtesy Beechview Area Concerned Citizens.)

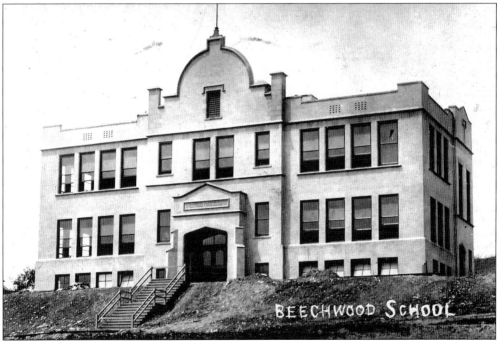

Before 1908, the residents of West Liberty Borough paid tuition to Beechview for their children to attend the Beechview School. In 1908, West Liberty built its own schoolhouse, a white-brick structure that was named the Beechwood School. The schools were united as one in 1909, when both boroughs merged with the city of Pittsburgh. (Courtesy Paul Dudjak.)

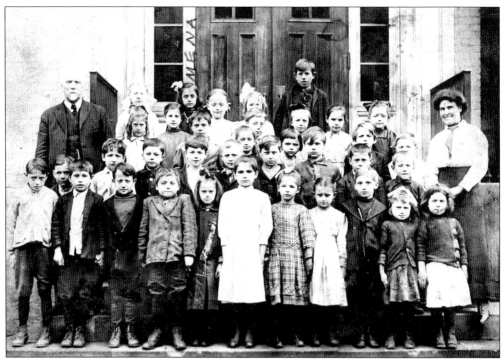

Younger students and two staff members gather outside the Beechwood School about 1915. Little Renata "Mena" Petri stands in the last row, second from the left. Mena was born on October 15, 1908. (Courtesy Pauline Petrucci.)

Members of the eighth-grade graduating class pose with their teacher in June 1917. It was a serious time; the country was at war. One wonders which of these students went on to attend the new South Hills High School and which ones marched off to join the army. Those pictured are not identified. (Courtesy Beechwood School.)

The burgeoning population of the neighborhood placed enormous pressure on the two elementary schools. Restrictions on construction, due to the war effort, forced temporary solutions to the overcrowded conditions, including double sessions and the installation of four "portables" adjacent to the Beechwood School. This 1917 view shows the interior of one portable structure. (Courtesy Historical Society of Western Pennsylvania.)

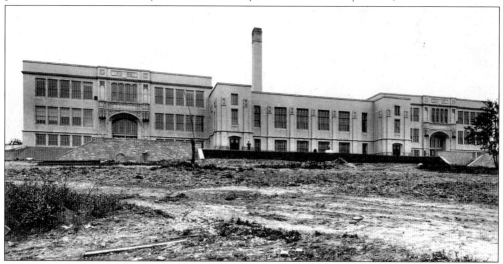

Following World War I, Beechview's total population grew from 30,445 in 1920 to 41,479 in 1930. To meet the challenge of overcrowding, architect Press C. Dowler was contracted to enlarge the Beechwood School in 1922. The addition was dedicated on May 14, 1925. The new building had a capacity of 700 students. The school is located on Rockland Avenue and continues to serve the children of Beechview today. (Courtesy Historical Society of Western Pennsylvania.)

Here is a view of the new kindergarten room in the late 1920s. Note the charming animal frieze along the wall. (Courtesy Beechwood School.)

The photograph on the cover of this book shows students tending a garden in 1916. In later years, students participated in the Nature Study Club, which met every Friday afternoon, as pictured here. The students made informal field trips to nearby meadows and woods to study the flora. In a 1927 school survey, school principal Xina Lang commented on the club and the abundance of violets blooming in Beechview in the spring. (Courtesy Beechwood School.)

In the midst of the Depression, the graduating class of 1934 and members of the school staff assemble for a portrait on the steps of the Beechwood School. Carmen Marini stands on the far right in the third row. Among the individuals in the fourth row are school librarian Miss Hinkley (second from the left), school principal Xina Lang (third from the left), and physical education teacher Miss Sankey (sixth from the left). (Courtesy Beechwood School.)

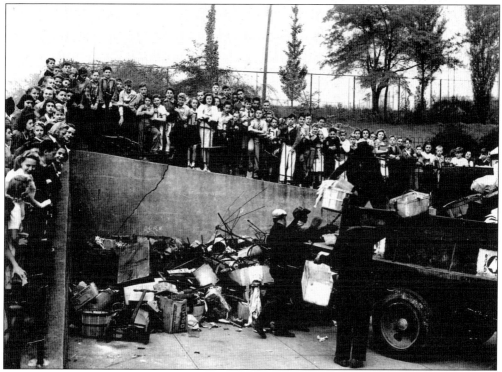

This image reveals the efforts of area students to support the troops during World War II. A three-day "Scrap Drive" in September 1942 netted 9,200 pounds of metal. Students proudly pose here behind the Beechwood School. (Courtesy Beechwood School.)

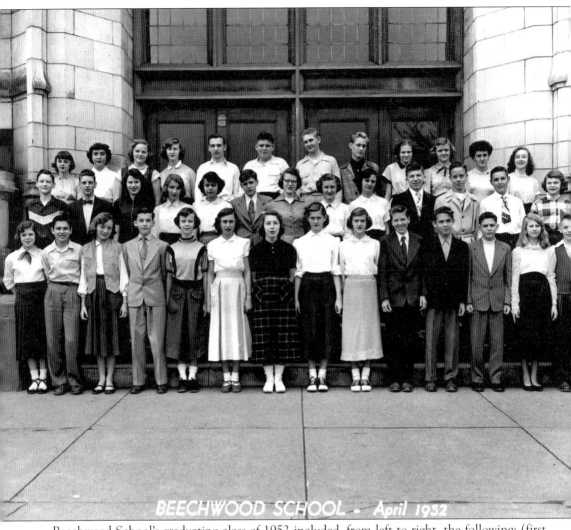

Beechwood School's graduating class of 1952 included, from left to right, the following: (first row) Pat Coberly, Carl Peroni, unidentified, Charles Mertz, two unidentified students, Judy Kaufman, two unidentified students, Joe Barry, Carl Lippi, Sammy Diodati, unidentified, and Larry Long; (second row) Bruce McKinley, Nick St. George, Nancy Nist, Virginia Fox, unidentified, Donald Dyson, Ann Johnson, two unidentified students, Ernest Burti, Donald Takach, Joseph Shaffer, and Jean McCann; (third row) unidentified, Marion Sapsara, Roberta Burns, unidentified, Sam Godino, Robert Weber, George Thielmann, Robert Klingensmith, Sally Warden, unidentified, Beverly Gentoli, and Judy Garland. (Courtesy Joseph Shaffer.)

The Beechwood kindergarten class is pictured in 1960. The dress style has altered, but the faces are just as fresh and eager as those in the 1920s class (seen on page 20). Note that the same charming frieze still graces the wall. It remains today. (Courtesy Beechwood School.)

The Beechwood School Boys' Choir was directed by Geraldine Ruch in 1952. Two famous Pittsburghers are pictured here. Jake Milliones (second row, second from the right) served as president of the Pittsburgh Board of Education and was a city councilman. Ron Lengwin (fourth row, second from the left) made his television debut in 1952–1953, when he sang a solo with the choir on WDTV–Channel 3. Father Ron now serves the Catholic Diocese of Pittsburgh. (Courtesy Beechwood School.)

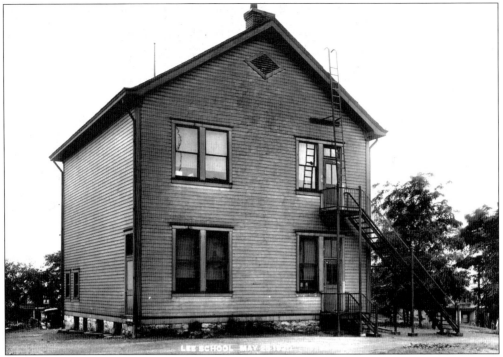

This two-room frame building facing Vodeli Street was erected in 1910. Shown here in 1921, it served as the first Lee Elementary School. It was named after Samuel R. Lee, a member of the local school board. (Courtesy Historical Society of Western Pennsylvania.)

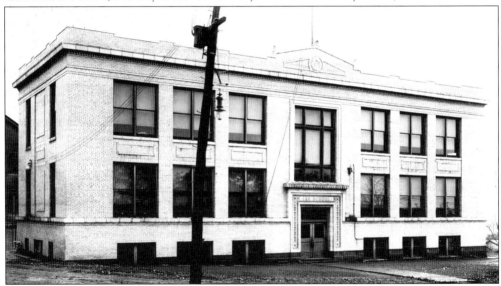

In 1911 a new white-brick structure was built adjacent to the first Lee School, at the corner of Los Angeles and Shiras Avenues. The plans were designed by the firm of Bartberger, Cooley, and Bartberger. The wood frame schoolhouse (seen in previous photograph) was temporarily abandoned, until 1913, when it was used as an annex to house the kindergarten class. In 1926, an addition was built to the main school that included four classrooms and an auditorium-gymnasium. The annex was again abandoned. (Courtesy Historical Society of Western Pennsylvania.)

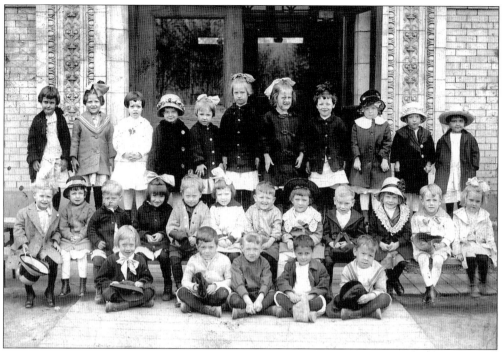

This group of young students is assembled in front of the new Lee School *c.* 1913. (Courtesy Janet Felmeth.)

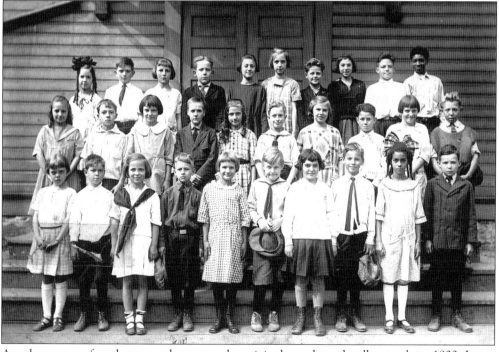

Another group of students stands next to the original wooden schoolhouse about 1922. James Rosfeld, holding his cap at his side, is in the first row, fourth from the left. James was born on December 9, 1912. The other students are not identified. (Courtesy Janet Rosfeld.)

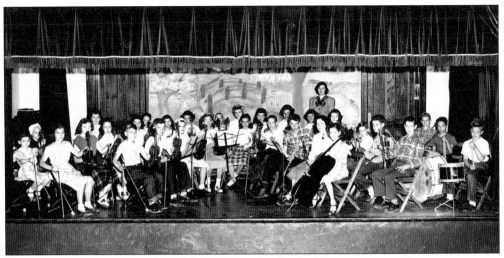

Music and the arts were emphasized in Pittsburgh schools. Mastering stringed instruments was no easy task. Here, in 1947, the Lee School Orchestra prepares for its annual spring concert. The teacher is Evelyn Dumais. (Courtesy Bob Brown.)

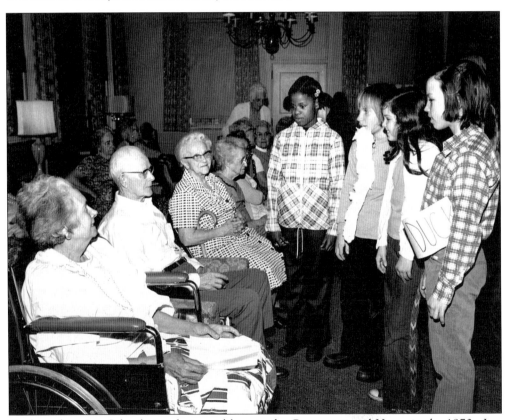

Students from Lee School visit their neighbors in the Congregational Home in the 1970s. Lee School closed in 1980, and the property was sold to the city of Pittsburgh in 1981. The building was later remodeled and now serves as Gualtieri Manor. (Courtesy Historical Society of Western Pennsylvania.)

St. Catherine's School opened in February 1915 under the instruction of two Sisters of St. Joseph and two lay teachers. Pictured here is the original building. The school soon became inadequate for the increasing number of students, and in 1918, a second story with four additional classrooms was built. The church and school were both enlarged in 1925. (Courtesy St. Catherine's Church.)

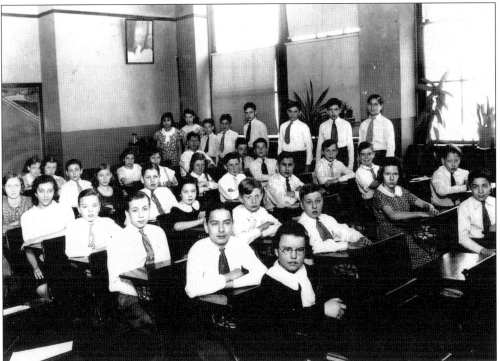

This interior view of St. Catherine's School shows a seventh-grade class about 1934. On November 15, 1953, a two-story addition with eight classrooms and a gymnasium was dedicated. (Courtesy Pearl Ehrenberger.)

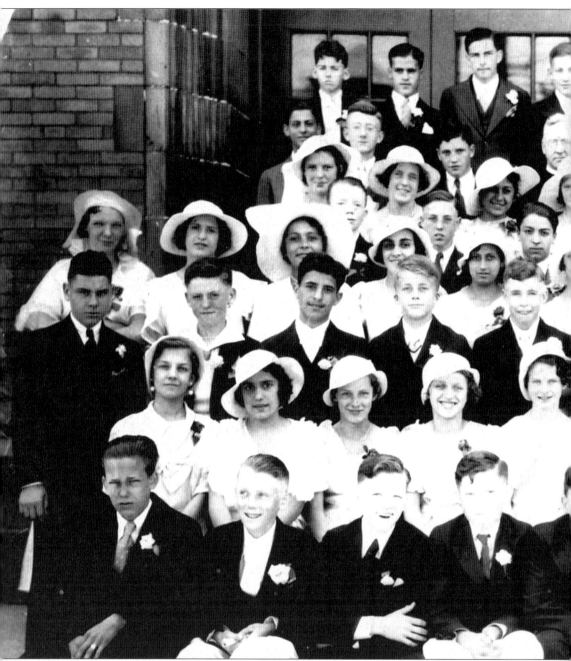

Here is St. Catherine's graduation class of 1933. From left to right are the following: (first row) Jack Leonard, Jack Miller, Jack Hook, Ed Worden, Joe Popella, Andy McGlynn, Carl Shiffhauer, Jim Immekus, Ralph Keighley, and Ray Walsh; (second row) Anna Kinkula, Julia Michelucci, Monica Tribus, Betty Ludwig, Eileen Duffy, Margaret Moribito, Eileen Coolihan, Theresa Puzzini, Mary Paledino, Rosalia Simmindinger, and Theresa Marinpietro; (third row) Vic Donahue, Bob Hagan, Ernie Bonaddio, Florence Mansman, Bill Lawrence, Walter Bruno, Jack Evans, Joe Daven, Bob Farmerie, Jim Lloyd, and Charles Deitman; (fourth row) Patricia Larkin, Lillian Danese, Millie ?, Florence Bruno, Marie Caliguire, Betty Donaldson, Auroa Maturi,

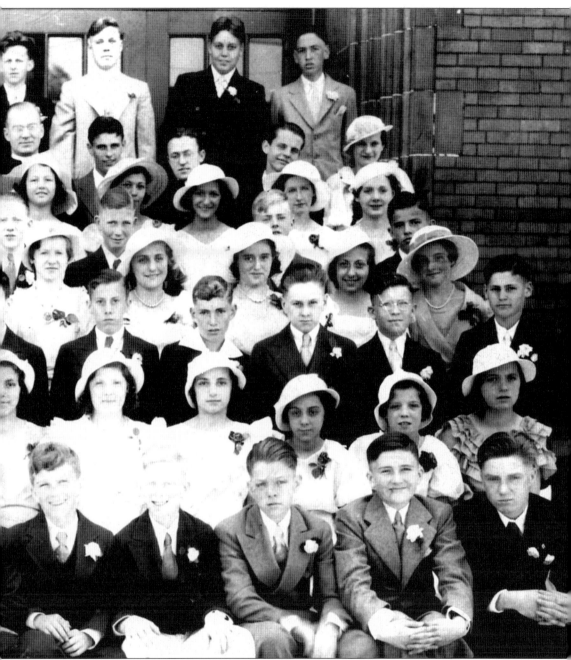

Wilemina Monning, Sara Maroney, Silvia Rizzo, and Anna May Carroll; (fifth row) John Mogan, Jack Cronin, Ralph Nudo, Tom Sloan, Al Hodgson, Walter Lair, and Leo LaSota; (sixth row) Betty Eberle, Ruth Vandergriff, Louise Maghugan, Mary Elizabeth Thomas, Dorethy Rupple, Mary Brett, and Angie Minette (two of the girls in this row are not identified); (seventh row) Tony Senopole, Bill McNamarra, Rusty Worden, Father Ralph L. Hayes, Father James M. Hanlon, John Joyce, Father George T. Sullivan, Ed Von Heddeman, and Virginia Leahy; (eighth row) Bob Coyne, Tony Folino, Pete McMonigle, Bob Waggoner, Jim Mendel, Bob Meehan, Harry Drew, and Justin Brown. (Courtesy Mary Farmerie.)

In the spring of 1946, the fourth-grade class is seated outdoors on the grounds of St. Catherine's School. (Courtesy Patricia Murphy Burgess.)

This eighth-grade graduation photograph at St. Catherine's School was taken in June 1960. The students are assembled on the Pauline Avenue side of the building, along with their teacher, Sister Mary Bernard. Due to declining enrollment, the school closed its doors in 1998. (Courtesy Eileen Coyne Mares.)

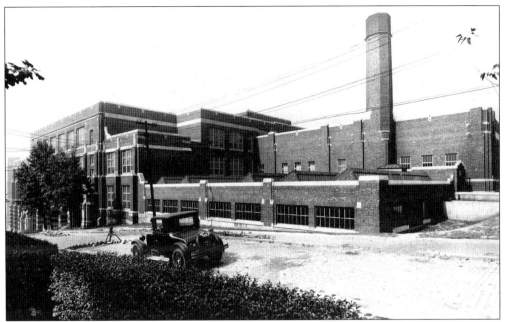

For 69 years, South Hills High School in Mt. Washington served generations of teens from Banksville, Beechview, Brookline, Knoxville, and Overbrook. The original Ruth Street wing opened on April 7, 1917, two weeks after the country entered World War I. The space accommodated 225 pupils. (Courtesy Historical Society of Western Pennsylvania.)

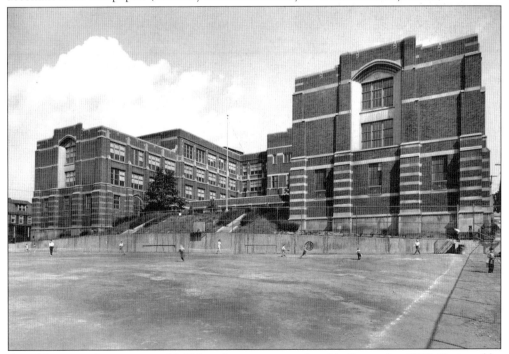

An addition, with a capacity of 2,000 students, was completed in September 1926. Designed by architects Alden and Harlow, the completed structure occupied a city block. (Courtesy Historical Society of Western Pennsylvania.)

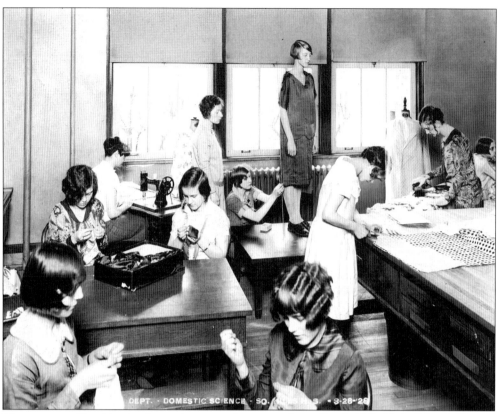

Classes were offered in the domestic arts and stenography at South Hills High School. Here, a sewing class is pictured in 1926. (Courtesy Historical Society of Western Pennsylvania.)

Alma Mater, now and ever, may we raise our song to thee. Every son and every daughter pledging love and loyalty.

When at last we leave thy portals, when in devious paths we stray, make thy light to shine upon us, showing us the perfect way.

The South Hills High School "Alma Mater" was published in the 1955 yearbook, *Sesame*. A second addition to the high school was completed in 1969. Commencement exercises for 179 seniors on June 17, 1986, marked the end of the 69-year history of the red-brick high school on Mt. Washington. (Courtesy Doris Priore.)

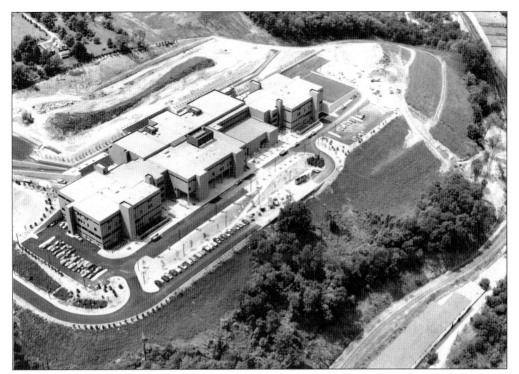

Brashear High School was erected in 1976 to comply with a state mandate to desegregate the Pittsburgh Public Schools. The architects were Curry, Martin, Highberger, and Klaus. Eugene G. Khorey served as the first principal. Brashear occupies about 400,000 square feet of former Beechview farmland, as seen in this aerial view. (Courtesy Historical Society of Western Pennsylvania.)

Shown here is the cover of the first edition of the Brashear yearbook, *Stargazer*. The title is a tribute to the school's namesake, John Alfred Brashear (1840–1920), noted Pittsburgh telescope lens maker, astronomer, and chancellor of the University of Pittsburgh. (Courtesy Brashear High School.)

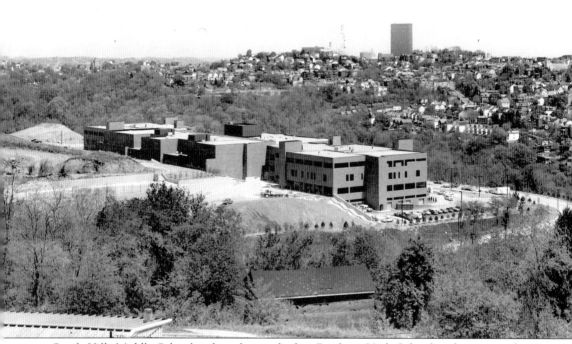

South Hills Middle School is directly attached to Brashear High School and serves grades six through eight. The middle school opened on September 7, 1996, with Bernard J. Komorski as the first principal. In this rear view of the building, the middle school is located on the far left. The U.S. Steel building towers over the top of Mt. Washington in the background. (Courtesy Historical Society of Western Pennsylvania.)

Seven

FAITH

Beechview is a community of religious expression. Over the years, the town has welcomed many churches and one synagogue. These places of worship have served as anchors for family devotion and have played an essential role in the life of the community.

It is thus, indeed, a strange reality that the person most associated with the expression of atheism should be a native of Beechview. Madalyn Mays Murray O'Hair was born in Beechview on April 13, 1919. The city directory for 1919 indicates that the Mays family lived at 1540 Beechview Avenue. Her mother, Lena Christina Scholle, was Lutheran; her father, John Irwin Mays, was Presbyterian. Founder of the American Atheists, Madalyn is most remembered for her famous crusade that led to the 1963 Supreme Court ban on school prayer.

Early churches in the area—Methodist Episcopal, Baptist, and Christian—were not located on the ridge. Folks would often walk to church. Children would walk barefoot to save shoe leather, putting on their shoes just before they arrived at church. Some families traveled to church services by wagon or buggy. As the population grew on the ridge, so did the desire to build houses of worship closer to the neighborhood. Today, eight churches serve people of many faiths.

St. Catherine of Siena Roman Catholic Church, named after a 14th-century guardian of the Roman Catholic Church, became a parish on July 2, 1902. Rev. John O'Brien was appointed the first pastor. The original sanctuary stood at 738 Wenzell Avenue. Father O'Brien built a second church at Rutherford and Hampshire Avenues. A new combination church and school was constructed on Broadway Avenue in 1914, and the school opened in February 1915. A second story was added in 1918. The church and school were further enlarged in 1925, and a two-story addition and gymnasium were built in 1953. The present church sanctuary was dedicated on April 30, 1963. St. Catherine's claims the unique distinction of serving as the mother parish of five other churches: Resurrection Church in Brookline (1909), St. Bernard of Mt. Lebanon (1919), St. Margaret in Green Tree (1931), St. Pius X in Brookline (1953), and St. Pamphilus (1960).

The Jewish community grew and flourished as more families moved to Beechview. The Jewish Mothers' Club was founded in 1917 by Rebecca Ruderman, who went door to door seeking other families who might be interested in forming a religious school for their children. Twenty families committed to the endeavor, hired a teacher, and sought a location for classes. Simultaneously, the men were seeking a place to gather for prayer. Granted a charter under the name Beechview Hebrew Congregation Beth El in 1919, the community built its synagogue at 1910 Broadway Avenue.

The Beechview Christian Church likely began as a church established in 1884 in Banksville. The congregation moved to Beechview around 1911, and built a beautiful brick Gothic Revival church on the corner of Broadway and Shiras Avenues around 1926. The church, part of the Disciples of Christ brotherhood, closed its doors in the late 1960s. In the 1970s, the building housed the Lee School kindergarten. Today, the structure serves as the home of Mercy Behavioral Health. (Courtesy Nate Marini.)

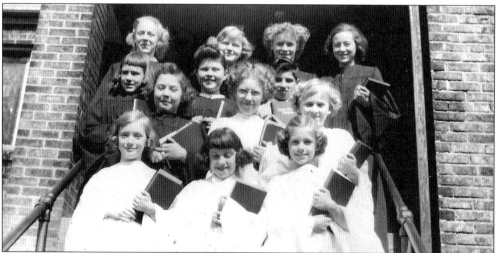

The Beechview Christian Church Junior Choir poses on the church steps in 1950. From left to right are the following: (first row) two unidentified girls and Laura Phillips; (second row) Donna Payne, Marilyn Mattison, and unidentified; (third row) Carol Bell, Joan Rebol, and Richard Vickers; (fourth row) Beverly Link, Georgia Murray, Helen Kennan, and Janet Felmeth. (Courtesy Janet Felmeth.)

In 2002, the parishioners of St. Catherine of Siena Roman Catholic Church celebrated the church's centennial. The first parish church, a humble frame building constructed at 738 Wenzell Avenue, is pictured as it looks today. (Courtesy Nate Marini.)

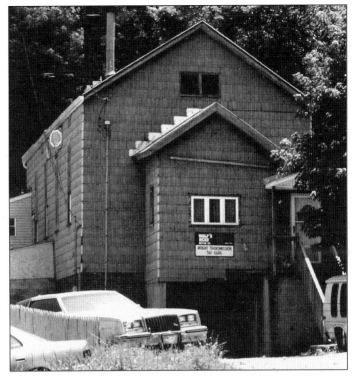

St. Catherine of Siena has hosted hundreds of weddings. Here, on July 14, 1962, the Vennare-Coghill marriage was blessed in the basement sanctuary. The cornerstone of the new church was laid on August 15, 1962, and it was dedicated on April 30, 1963. (Courtesy Lee McKenzie.)

The Beechview Methodist Episcopal Church began in the home of Herman B. and Agnes Mertz, and it is where interested families met for Sunday school. At the Mertz home, the church was officially organized on May 14, 1905. A brick Gothic Revival building with a crenelated tower was constructed at the corner of Sixth and Pennsylvania (Methyl and Hampshire). One can still read the street names engraved on the side of the church. The students of Beechview attended school in the church basement until their new school was

completed in 1906. The church thrived for many years, but eventually enrollment declined, and the remaining members merged with the Dormont Methodist Church. Since 2001, the building has served as spiritual home to the Three Rivers Grace Community Church. This c. 1905 panoramic view of west Beechview shows the newly built Methodist church and the sparsely developed rolling hills surrounding it. The new wooden sidewalks are clearly visible. (Courtesy Barbara Haggerty.)

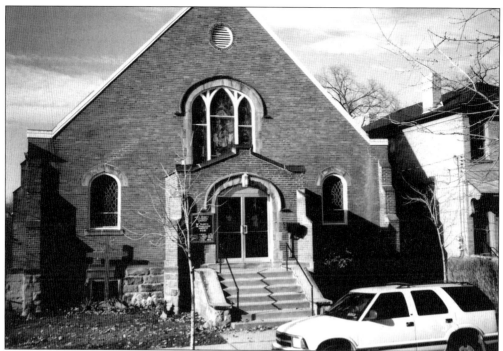

During the winter of 1905–1906, the Home Mission Board of the Pittsburgh Synod became interested in the developing community of Beechview. On February 3, 1907, the Holy Trinity Evangelical Lutheran Church was organized, with Rev. G. M. Heindel serving as the first pastor. A portable chapel established on Eighth Avenue (Fallowfield) was dedicated on May 12, 1907. The first Sunday school classes met there. The permanent sanctuary was constructed and dedicated in 1911. (Courtesy Nate Marini.)

The Grandview Church of God began life in Mt. Washington as part of the International Denomination of the Church of God. In 1970, the church acquired the First German Evangelical Protestant Cemetery (now Grandview Cemetery) in Beechview. After acquiring additional property in 1971, the church expanded the cemetery. In 1978, this current two-story church was built, and a parsonage was completed in 1982. (Courtesy Nate Marini.)

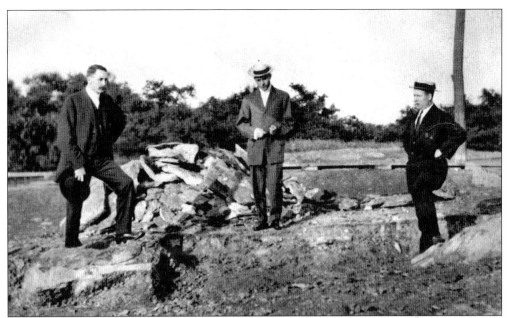

The Reorganized Church of Jesus Christ of Latter-day Saints met in Allegheny City as early as 1861. In 1910, a few families began gathering in their Beechview homes. Together, they purchased a lot at the corner of Tonopah and Realty Avenues. Overseeing the groundbreaking for the new church in 1912 are Charles Fry (left), L. F. P. Curry (center), and Joseph Jacques. (Courtesy Community of Christ Church.)

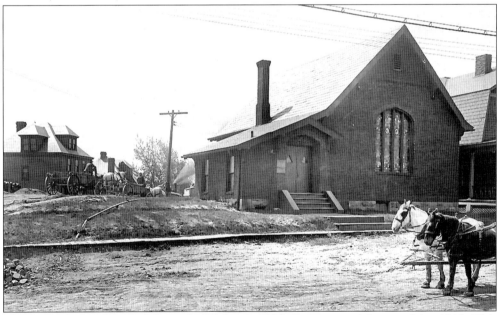

The original church was dedicated on May 1, 1921. It is pictured here in May 1916. This diminutive structure is architecturally interesting, with its rustic styling and cottage-like details. The church windows are especially lovely and vibrant with cobalt blue borders. An educational wing was added in 1955. Since April 2003, the sanctuary has served the denomination of the Community of Christ. (Courtesy University of Pittsburgh.)

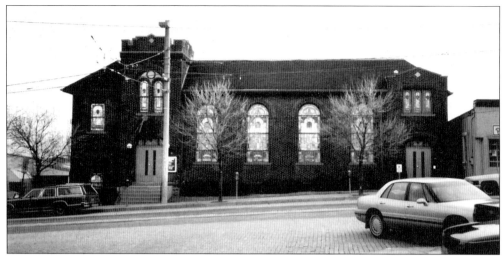

A Presbyterian congregation formed in Beechview and was incorporated in the Allegheny County Court of Common Pleas in 1915. The group temporarily worshiped in a local movie house until the sanctuary was built at 1621 Broadway Avenue. The date stone reads 1917. This Beechview United Presbyterian Church is Romanesque Revival in architectural style and boasts several large stained-glass windows. This congregation is a member of the Pittsburgh Presbytery. (Courtesy Nate Marini.)

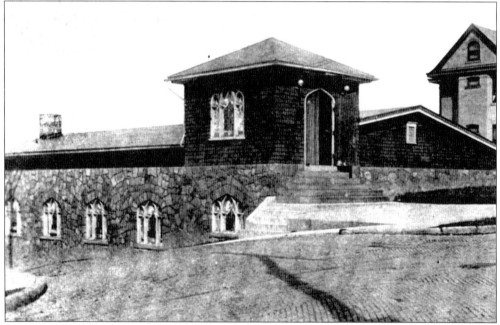

Several unhappy members of the Beechview United Presbyterian Church, along with those from other Presbyterian churches, formed a second Presbyterian congregation in Beechview and convened in an empty storeroom at 1530 Beechview Avenue. The Beechview Presbyterian Church broke ground during the summer of 1918 at the corner of Beechview and Sebring Avenues. The two church congregations remerged in 1937. This structure now houses the local fire department. The Vermont-stone foundation and the outline of the church windows remain visible today. (Courtesy Reid Scharding.)

Groundbreaking ceremonies for St. Pamphilus Roman Catholic Church were held on September 14, 1963. The first Mass was performed at midnight on Christmas Eve 1964. Parishioners had attended services at the former American Legion Hall in Beechview from December 8, 1960, until December 20, 1964. (Courtesy Anna Loney.)

Pittsburgh native Charles Taze Russell founded the religious organization known as the Jehovah's Witnesses. In 1879, Russell (1852–1916) published the first edition of the magazine called *Zion's Watch Tower* and organized the Watch Tower Bible and Tract Society in 1884. A Kingdom Hall of Jehovah's Witnesses was built in 2000 on property formerly owned by the Shaffer family. (Courtesy Anna Loney.)

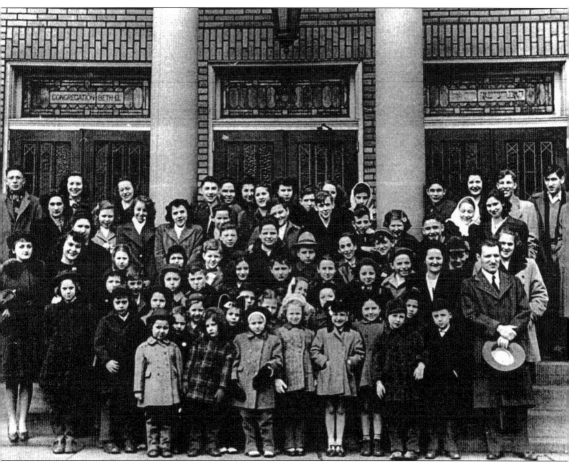

The Jewish Mothers' Club of Beechview was instrumental in establishing the Beth El congregation. Abandoning their plan for a community center, the mothers contributed their collected funds toward the purchase of a lot at 1910 Broadway Avenue for the construction of a place of worship. The Beth El Synagogue was completed in 1927. The congregation moved to Scott Township in the 1960s. Here, the members of the religious school are pictured in front of the original Beechview synagogue. (Courtesy Beth El Congregation.)

Eight

SPORTS AND
OTHER PASTIMES

The coach of the Pittsburgh Steelers, if asked today, might say that the spark that first ignited his interest in sports was lit in the intimate community of Beechview. A third-grade class photograph at the Beechwood School in 1966 reveals the smiling countenance of William Cowher. Young Bill most assuredly would have been exposed to the many and varied sports activities available in the community at that time. Our basketball teams, sponsored by local businesses, were fully organized by 1920.

If you were lucky enough to have been born in 1940s Beechview, you would have been present at the beginning of a tradition started in 1953 that has continued today. If you participated, your efforts and successes would have been rewarded each year at the end of the outdoor sports season with participation in a grand parade. As a Girl Scout or a member of the Little League, your presence in these parades is reported to have been extremely memorable. Through the winning years and the years simply spent in joyful participation, the children of Beechview could always look forward to the Little League Parade. It has been and continues to be the culmination of a community commitment to the wholesome exposure of sports and activities for our young. The annual parade is an opportunity to see and be seen, to celebrate accomplishments, and in the case of the many politicians who have attended over the years, a time to make promises for the future. The late mayor of Pittsburgh, David L. Lawrence, made it a point, on more than one occasion, to attend our parade. We understand from our photographs, and from the many stories told by our older citizens, that these parades were grand events.

Allowing our youngsters to play organized sports for the first time at Vanucci Field, our older athletes to hone their athletic skills at Alton Field, and our citizens to enjoy their playgrounds, Beechview's parks are community assets. They continue to be meeting spots, places of recreation and music, and spaces to experience the joy of community bonding.

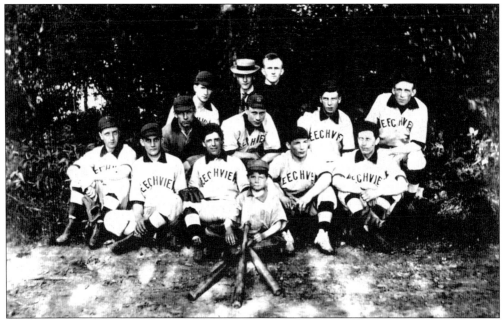

By the early 20th century, Beechview baseball had already been organized, formalized, and supported. (Courtesy Paul Dudjak.)

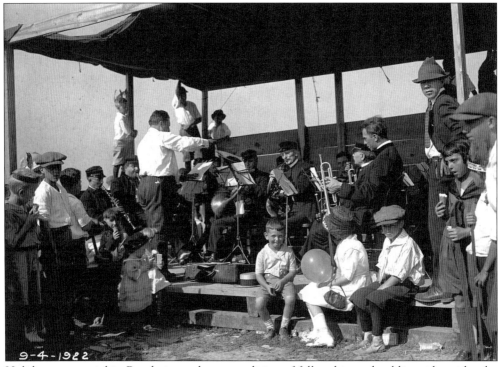

9-4-1922

Holidays are special in Beechview, where a tradition of fellowship and public pride guides the community. As illustrated in this photograph captured at a Beechview playground on Labor Day 1922, local parks provide a place where young and old can gather together. (Courtesy Pittsburgh City Photographer Collection, University of Pittsburgh.)

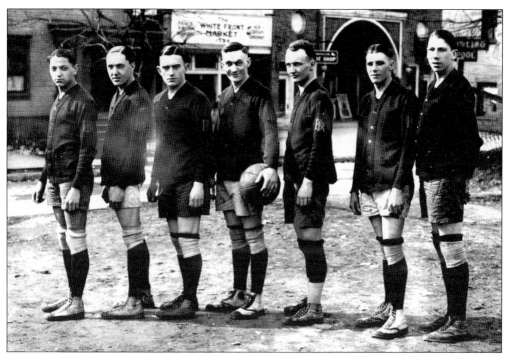

The White Front Market and the Olympic Theater provide the backdrop for this c. 1920s basketball team photograph. The Olympic Theater was one of two moving-picture theaters on Beechview Avenue at that time. The White Front Market was but one of many stores that operated at this spot. This team includes Elmer Haggerty (far right), who went on to operate Johns' Drug Store with his brother George. (Courtesy Barbara Haggerty.)

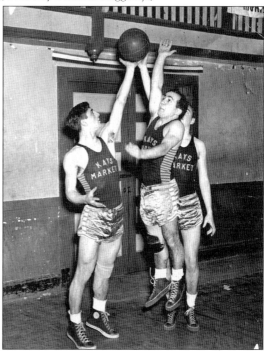

Sponsorship was vital to basketball teams and was the order of the day, as evidenced by the jerseys seen in this 1940s action photograph. Kay's Market was among the many establishments that financially supported local teams. Here, three of Beechview's finest show their stuff on the court: Tony Marini (left), Ray Mancuso (center), and ? Parker. This shot was made in Boylan Hall—no pun intended! (Courtesy Ray Mancuso.)

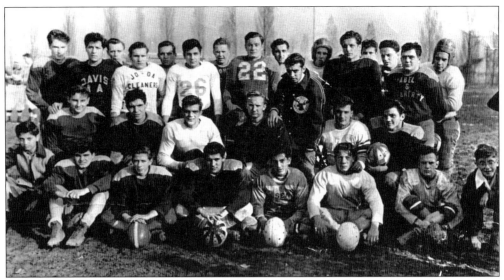

Sandlot football was a rough-and-tumble game. While this sandlot squad may appear to be a ragtag bunch, the team actually went all the way to capture the championship in 1950. This picture was taken at Alton Field, with the Beechview School in the background. Joe Morobitto is in the second row, third from the left, wearing the white jersey. (Courtesy Joe Morobitto.)

BEECHWOOD SCHOOL
Dr. Thomas A. Burkhart, Prin.
Mrs. Loretta Beede
Grade 3
1965 1966

Beechview's own Bill Cowher, now coach of the Pittsburgh Steelers, is pictured with his fellow third-graders from the Beechwood School. (He is in the top row, second from right.) Cowher currently holds the distinction of being the National Football League's longest-tenured coach with one team. He has captured 8 division titles in 13 seasons with the Steelers, including the 2004 AFC North division title. Cowher lived on Orangewood Avenue and attended the Beechwood School between 1962 and 1966. (Courtesy Roberta Hammill Saunier.)

Deno Vanucci was a hardworking house painter who died at the age of 87 on December 2, 1978. Founder of the Duckpin Bowling Association and the Beechview Little League, he was also former president of the Beechview Lions Club. Through his efforts, the current Little League field was realized when the earth removed from the Fort Pitt Tunnels in the 1950s was used to create Vanucci Field. The field rightfully bears his surname. (Courtesy Gregory Vanucci.)

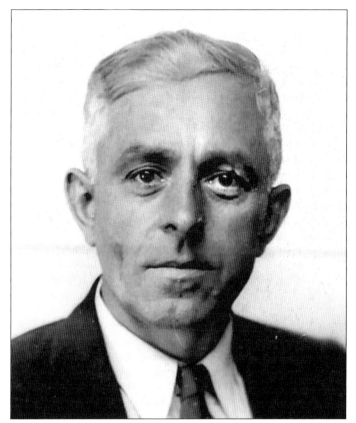

A banner welcomes visitors to this premier field. The area, once a large hollow, became "solid ground" through the efforts of local citizens like Deno Vanucci, in cooperation with the city of Pittsburgh. The snack bar remains a favorite meeting place. (Courtesy Beechview Area Concerned Citizens.)

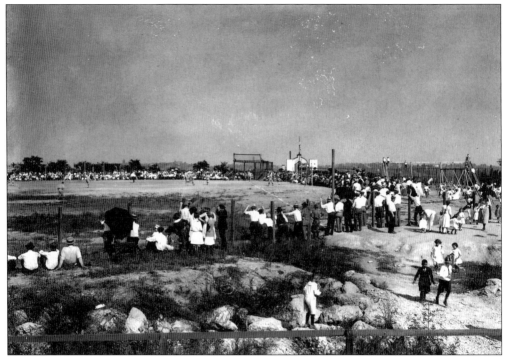

Alton Field (the American Legion Field) was the home field and playground of many teams over the years. Here, fans gather to watch a game in 1922. If you were lucky or skilled enough to advance from the ranks of the Little League at Vanucci Field, your efforts were rewarded by promotion to the "big kids" field. Home of the Pony League, Alton has been the site of pickup and sandlot teams, as well as organized and sponsored teams. (Courtesy Pittsburgh City Photographer Collection, University of Pittsburgh.)

Pauline Park, although not a location of championship teams, is a popular recreation and meeting place that has made a mark on the community. Some of its citizens have made a mark on it as well—the cement whale seen in the foreground came to us through the masonry skills of Joseph Della Vecchia. (Courtesy Beechview Area Concerned Citizens.)

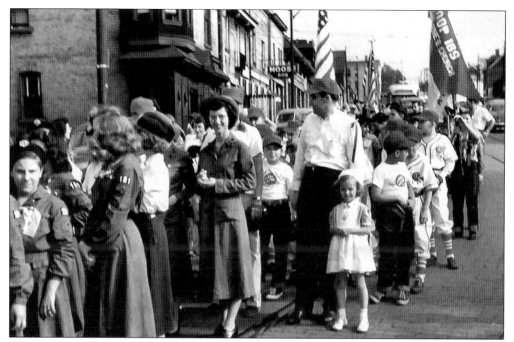

The tradition of the Little League Parade began in 1953. The celebration was, and continues to be, the culmination of summer activities well spent. This photograph from the first-ever parade reveals that it is not just for the Little Leaguers, but also for local Girl Scouts. The Cubs Little League team, seen here with coach William Dillon, was one of four teams that year. (Courtesy Betty Meyer Dillon.)

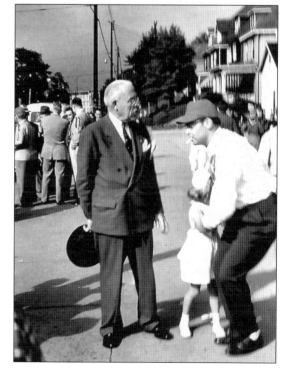

What politician worth his salt would not use the Little League Parade as an opportunity to mingle with constituents? The architect of Pittsburgh's first Renaissance, Mayor David L. Lawrence (left), speaks with Beechview residents in 1953. Lawrence was the first mayor to walk the route, but he was certainly not the last. (Courtesy Betty Meyer Dillon.)

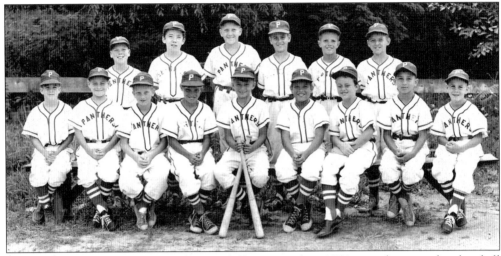

Panthers, who once roamed Beechview's hills, returned in 1951 as a championship baseball team. The young ballplayers, who started out in the Pony League at the time, would soon see the emergence of a viable Little League. The Pony League played regularly at Alton Field. (Courtesy Nate Marini.)

The Lee Community Club, a social and welfare organization, met twice a month at the Lee Elementary School in the 1920s and 1930s. The membership in 1927 included about 80 local women. Depicted here c. 1934 is one of the group's theatrical presentations. The blue eagle symbol of the Depression's National Recovery Act is visible at the back. Only a few of these women are identified: ? Roger is in the first row, at far left; Bertha Brown is in the second row, third from the left; and Ida Johnson Barker is in the second row, fifth from the left. (Courtesy Bob Brown.)

This June 1956 image was taken at the height of the country's bowling craze. And in Beechview, organized bowling was in full swing. Assembled here are members of the St. Catherine's Christian Mothers Bowling League. While not all of these women are identified, among those pictured here are: (first row) Florence Coyne, Florence Burgess, and Nancy Burgess; (second row) Rose Berardi, Betty Ruffenach, and ? Winkowski; (third row) Eleanor Forney, Marcy Michaels, and ? Radolec. (Courtesy Florence Burgess Coyne.)

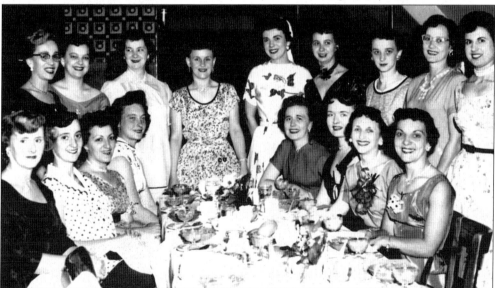

By 1954, the number of Italian residents had grown to approximately 70 percent of Beechview's population. The Italian Sons and Daughters of America organization shows off its daughters at this 1954 Beechview Lodge Bowling Club dinner. Pictured from left to right are the following: (seated) Marlene Weslager, Lucille Daniele, Isabel Simasek, Louise Milkovich, Betty Lowther, ? Collins, Helen Cerminara, and Frances Bauer; (standing) Rose Cutrone, Sis Forte, Dot Gaetano, unidentified, Betty Priore, Dolly Gray, Joan Fest, Joan Gaetano, and Grace Bretti. (Courtesy Joan Mascaro Gaetano.)

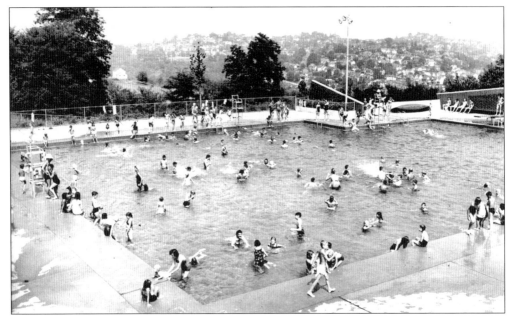

Since the 1954 construction of the Beechview Pool, people have flocked to these cool waters for relaxation, recreation, and the view. During the construction of the U.S. Steel building—the tallest building located between Chicago and New York—folks could view the upper floors' formation straight across from the Beechview Pool. As a cost-cutting measure, the city closed many of its pools in 2004, including the Beechview facility. The future of the local pool's use is unknown. (Courtesy Historical Society of Western Pennsylvania.)

Move over boys! Alton Field has played host to both genders over the years. In this 1981 photograph, members of the champion girls' softball team are, from left to right, as follows: (first row) Joann Williams, Lisa Faloon, and Michael-Ann Williams; (second row) Cindy Springel and Cindy Radolec. (Courtesy Patricia Faloon.)

Nine
A PROLOGUE
TO THE FUTURE

On February 23, 2004, local residents and civic leaders gathered at the Carnegie Library of Pittsburgh, at 1910 Broadway Avenue, to organize a possible celebration of the 2005 centennial of Beechview. The original members of the Beechview Centennial Celebration Committee (BCCC) included Florence Coyne, Jean Cummings, Richard Dabecco, Phyllis DiDiano, John Gratner, Lynn Griffin, Meredith Gray, Kathy Hillen, Robert Hillen, Anna Loney, Christina Long, Ellen Magnotta, Daniel Mitchell, Rose Marie Motznik, Stephen Nemmer, Carol Schreiner, Theresa Seibert, Robert Thomas, John Vater, Judy Williams, and Tina Zubak. Audrey Iacone served as chairperson.

The enthusiastic group quickly formed subcommittees, accepted new members, and planned for the pursuit of relevant activities. Committees for fund-raising, a Web site, centennial quilt, history book, cookbook, community logo contest, school essay contest, time capsule, banners, and tree planting were organized. The logo contest committee planned a communitywide contest in May from which four winning images were selected. The images (or parts of them) will appear on the quilt, banners, stationery, and other centennial items.

Saturday, July 23, 2005, was designated the official celebration day. A dedication of the time capsule and a community parade will be held on that date. An ecumenical church service is scheduled for Sunday, July 24.

At the start of the 21st century, Beechview residents are poised to meet their future with energy, intelligence, and enthusiasm. Their second century awaits them. We wish them Godspeed.

In July 2055, the time capsule is to be opened. Will we find you there?

There will be stars over the place forever;
Though the house we loved and the street we loved are lost . . .
There will be stars over the place forever,
There will be stars forever, while we sleep.

—Sara Teasdale (1884–1933)

Winning entries in the communitywide logo contest appear on the following pages. "Trolley and Other Beechview Symbols," shown here, was drawn by Krystin Cunningham of Brashear High School.

Jessica Viszneki of Beechwood Elementary School created "My House and Neighborhood."

"Faces of Beechwood School" was drawn by Isaac McHirella of Beechwood Elementary School.

BEECHVIEW... A BETTER VIEW

J.J. LENDL

J. J. Lendl, a graduate of Brashear High School and student at Washington and Jefferson College, created "Beechview Tree."

127

BEECH VIEW 100

BEECHVIEW
CENTENNIAL CELEBRATION
1905-2005

This Beechview centennial emblem was designed by former Beechview resident Dennis Moran of Dennis Moran Design. He met his wife, Margaret Morelli, when they both worked at Johns' Drug Store in the 1960s. This graphic is their gift to Beechview.